POSTCARD HISTORY SERIES

# Native Americans of Arizona

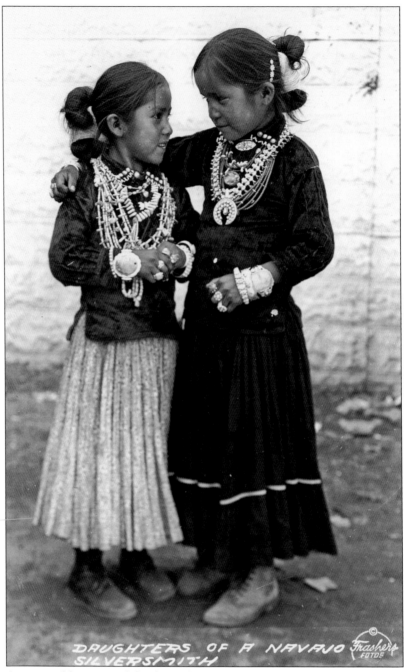

DAUGHTERS OF A NAVAJO SILVERSMITH

The Navajo are world renowned for their silver and turquoise jewelry. Here two daughters of a silversmith show off some of this handiwork.

ON THE FRONT COVER: Navajo ladies and children are shown in a camp setting, probably on a trip to town for trading. (Courtesy author.)
ON THE BACK COVER: This home on the San Carlos Apache Reservation in the 1930s includes the traditional domed wickiup house and brush shade. (Courtesy author.)

POSTCARD HISTORY SERIES

# Native Americans of Arizona

Paul and Kathleen Nickens

ARCADIA
PUBLISHING

Published by Arcadia Publishing
Charleston, South Carolina

Printed in the United States of America

Library of Congress Catalog Card Number: 2006939691

For all general information contact Arcadia Publishing at:
Telephone 843-853-2070
Fax 843-853-0044
E-mail sales@arcadiapublishing.com
For customer service and orders:
Toll-Free 1-888-313-2665

Visit us on the Internet at www.arcadiapublishing.com

Vintage postcards have long helped define the Native American makeup of the Southwest's Indian country, including the states of Arizona and New Mexico.

# CONTENTS

Acknowledgments                                          6

Introduction                                             7

1.   Navajo                                              9

2.   Hopi                                               35

3.   Western Apache and Yavapai                         61

4.   Desert Tribes                                      81

5.   Colorado River Tribes                              95

6.   Traders, Tourists, Missions, and Schools          109

Bibliography                                           127

# ACKNOWLEDGMENTS

The authors would like to thank our editor at Arcadia Publishing, Christine Talbot, publishing manager for the West, along with other staff at Arcadia for assistance and guidance in the preparation of this book. We also express gratitude to Dr. Jack L. August, director of the Arizona Historical Foundation, for his encouragement and enthusiasm in support of the effort.

Our daughter, Lisa A. Costanzo, prepared the map in the introduction. We sincerely appreciate her endeavor to make the book more informative. All other images came from the authors' private collection.

# INTRODUCTION

In 2007, some 21 federally recognized Native American tribes and nations are located either wholly or primarily within Arizona's boundaries. Their population within the state is nearly 255,900 residents, comprising about five percent of the state's overall population and making Arizona the third-largest state for Native Americans in the nation. About 63 percent of the state's Native American residents live on reservations. Although traditional territories were significantly reduced in most cases, each of the present-day tribal communities is generally located in its original geographic setting within Arizona's Indian country.

Arizona Native Americans include the following sovereign nations (see accompanying map):

> Ak Chin Indian Community (Pima, Tohono O'odham)
> Camp Verde Yavapai–Apache Nation (Yavapai, Tonto Apache)
> Cocopah Indian Reservation (Cocopah)
> Colorado River Indian Tribes (Chemehuevi, Hopi, Mohave, and Navajo)
> Fort Apache Reservation (White Mountain Apache)
> Fort McDowell Yavapai Nation (Mohave, Apache, Yavapai)
> Fort Mohave Indian Tribe (Mohave)
> Fort Yuma Reservation (Quechan)
> Gila River Indian Community (Maricopa, Pima)
> Havasupai Reservation (Havasupai)
> Hopi Reservation (Hopi)
> Hualapai Reservation (Hualapai)
> Kaibab Band of Paiute Indians (Paiute)
> Navajo Nation (Navajo)
> Pascua Yaqui Reservation (Pascua Yaqui)
> Salt River Pima-Maricopa Indian Community (Maricopa, Pima)
> San Carlos Apache Reservation (San Carlos Apache)
> San Juan Southern Paiute Tribe (Southern Paiute)
> Tohono O'odham (formerly Papago) Nation (Tohono O'odham)
> Tonto Apache Reservation (Tonto Apache)
> Yavapai-Prescott Reservation (Yavapai)

Beginning in the late 1800s, tourism interest in Southwestern Native Americans was extensively promoted throughout the country. Around 1900, this promotion was epitomized by the efforts of the Fred Harvey Company and the Santa Fe Railway in New Mexico and northern Arizona. These efforts involved hotels, displays, craft demonstrations, dances, Native American crafts sales rooms, side tours to Native American villages, and a wide variety of images and publications designed to give Midwestern, Eastern, and often foreign tourists a maximum exposure to the fantasy of Native American life of this then largely unchanged part of the country. Within the general context of this touristic scene, souvenirs such as picture books, playing cards, brochures, and postcards served as important vehicles for both recapitulating and sharing one's experience in the "Land of Enchantment."

Postcards were particularly important as graphic representations of the Southwestern Native American experience. In addition to being inexpensive, they could be easily collected and

arranged into albums. Postcards were also effective for verifying the tourist's experience and offering the opportunity to send relatives and friends a brief description of the encounter. Because of this popularity, the Fred Harvey Company and other publishers produced a wide assortment of postcard images, covering, at least to some degree, cultural aspects of nearly every tribe extant in the region.

The following pages depict the lifeways of some of Arizona's Native Americans as illustrated in postcard images for the period running from about 1900 to the mid-1940s. Native American groups in Arizona include immensely diverse geographic and cultural differences. Some of these groups received significantly more tourist attention than others. For example, the Navajo and Hopi in the northeast part of the state were profoundly impacted by the efforts of the Fred Harvey Company and Santa Fe Railway and later by historic Route 66, which traversed through or near their reservations.

Vintage postcard views of Arizona Native Americans are organized herein by tribal and geographical distribution. Certain tribes, such as the Navajo, Hopi, and Apache, have dedicated chapters due to the large number of images produced. Others with fewer available views are grouped geographically. A final chapter includes early postcard images of non-native institutions that resulted in important changes to the Native American's cultural systems. These include institutions associated with trading posts, boarding schools, church-based missions, and non-reservation tourist enterprises. In the case of the latter, Native American villages were sometimes replicated, and the people were "imported" to enhance the overall tourist experience at places such as Grand Canyon National Park.

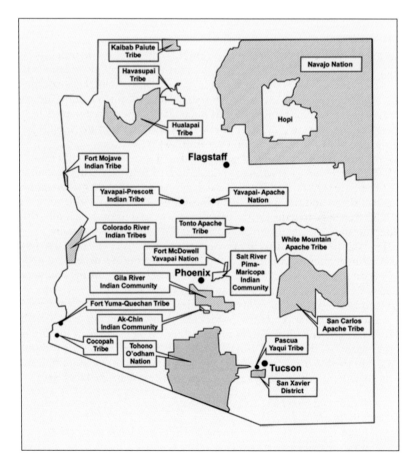

This map shows the present-day locations for Arizona's Native American tribes discussed in this book.

# *One*

# NAVAJO

Established by treaty in 1868, the Navajo Nation today comprises 26,890 square miles, lying primarily in northeastern Arizona with smaller areas in northwestern New Mexico and southeastern Utah. The reservation is home to more than 175,000 *dine* or "people," making it both the largest and most-populous Native American reservation in the United States. Located on the Colorado Plateau, the reservation is known for its scenic landscape, which ranges from arid deserts to alpine forests. Wind, water, and volcanic activity have formed the spectacular canyons, mesas, mountains, and deserts of the region over millions of years.

Navajos have likely been in the American Southwest for nearly a thousand years, migrating in earlier times, along with the Apache peoples, from the Athabascan culture area of north-central Canada. Having entered the Southwest as small, nomadic bands of hunters and gatherers, the Navajos acquired horses and sheep and the knowledge of working with metal and wool from the Spanish in the 1600s. These traits, together with agriculture acquired from the neighboring Pueblo Indians, have long defined the character of Navajo culture—a mixed economy based on agriculture and herding and the manufacturing of world-renowned silver works and woven textiles. As agriculture grew in economic importance, the Navajo became less dependant upon seasonal migrations and began to settle in small communities near fields. The distinctive house form, the hogan, developed as the primary habitation and ceremonial structure.

The extended kin group, made up of two or more families focused on a mother and her daughters, forms Navajo social organization. It is a cooperative unit of responsible leadership bound together by ties of marriage and close family relationships. Women hold an important social position within the nation. Religion and language are still the core of Navajo culture. Ceremonial sand paintings are used in healing rituals for many types of physical, emotional, and social imbalances. About 80 percent of the Navajo people still speak their native language.

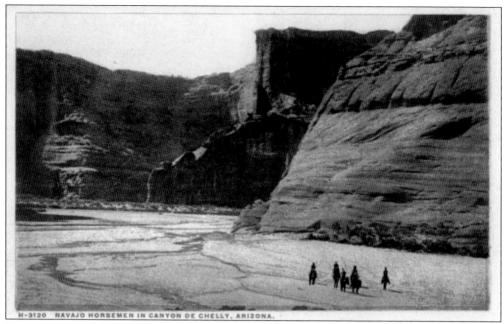

Many areas of the Navajo Reservation in northeastern Arizona are characterized by deeply incised canyons and mesas. Navajo horsemen are shown in this 1920s view passing through Canyon de Chelly, which is today a national monument area. Navajo people still seasonally cultivate fields and fruit orchards within the confines of the canyons.

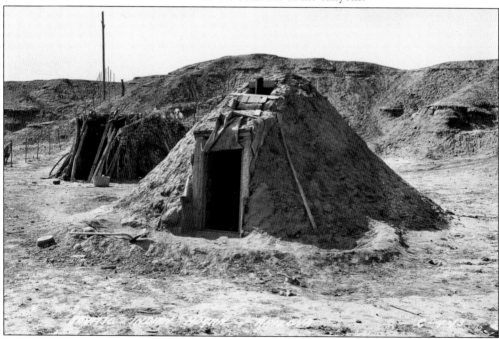

The traditional Navajo winter house was the conical, forked-pole hogan, formed by vertical, interlocking logs to which a final layer of mud was applied. In this 1930s view, the doorway is extended with a canvas flap and hole for the stove chimney. A brush shelter, used as the principal summer family residence, can be seen to the left of the hogan.

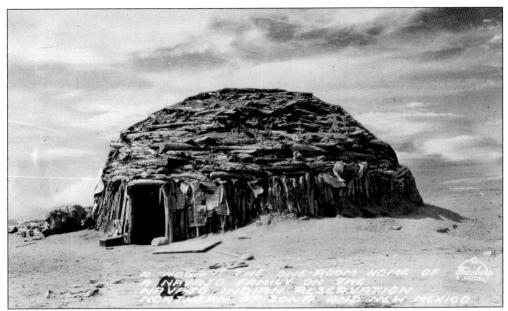

In this 1940s image, a later-style hogan is shown, constructed of vertical logs around the perimeter and with a cribbed log roof. Hogans had a single entry, oriented to the east and the rising sun so as to be able to catch the blessing of the day's first rays.

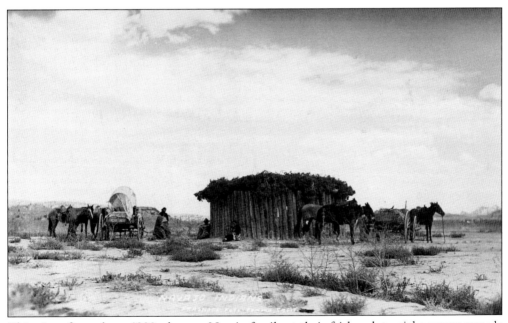

This view, from about 1930, shows a Navajo family at their fairly substantial summer ramada or shade, formed by vertical poles and brush roof. The principal forms of transportation of the time are reflected by the saddled horses and open and covered wagons.

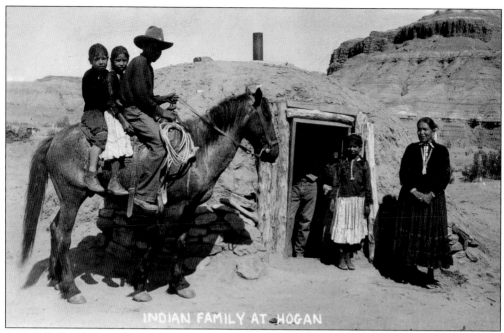

A Navajo family, posed in front of their mud-covered winter hogan, highlights this late-1940s image. The mother and daughters are dressed in the traditional early-20th-century calico skirts and velveteen blouses.

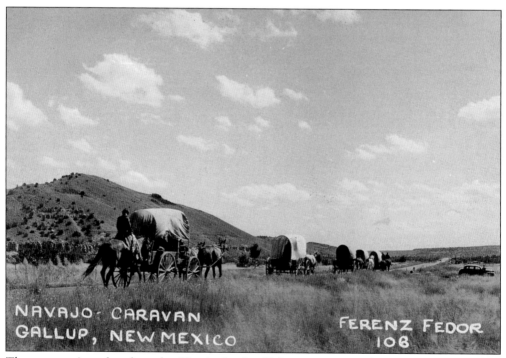

The wagon, introduced to the Navajo in the 19th century, was the principal vehicle for transportation before the pickup truck gained popularity on the reservation. In this 1940s view, several families form a caravan headed to town for trading and purchasing of supplies.

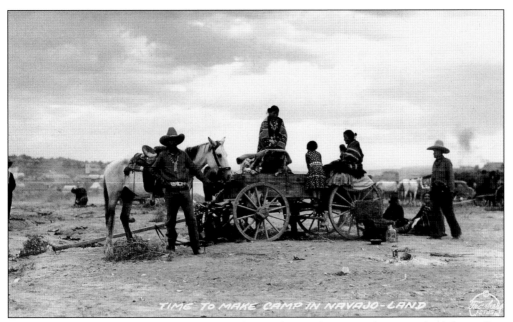

Once reached, camps were established on the outskirts of town and occupied while trading took place in the trading posts and shops. In this view from the early 1930s, a town, quite possibly Gallup, New Mexico, located on the southeastern edge of the reservation, can be faintly seen in the background.

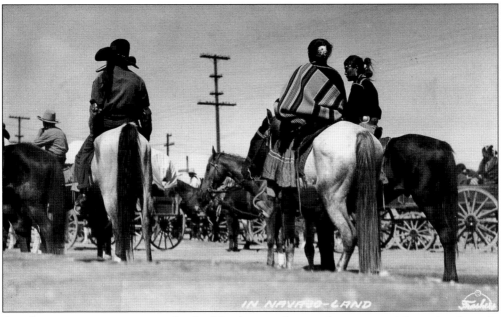

Another reason to go to town for the Navajos was for parades, ceremonials, and rodeos. In this view, Navajo men wear Anglo clothing, complete with cowboy hats, while the women are dressed in a more traditional style. The women's hair is tied in the conventional, double-loop style.

13

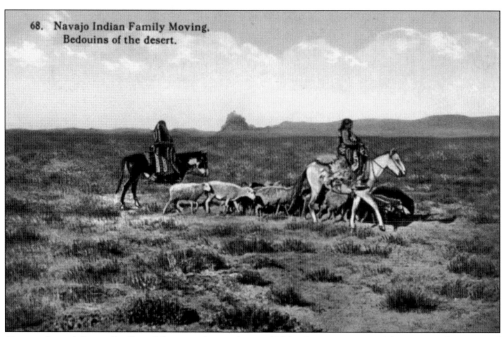

68. Navajo Indian Family Moving.
Bedouins of the desert.

Once adapted from the Spanish sometime prior to 1700, the Navajo quickly accepted a pastoral economy based primarily on the raising and herding of sheep and goats. The horse aided in the herding economy and expanded the range over which economic pursuits took place.

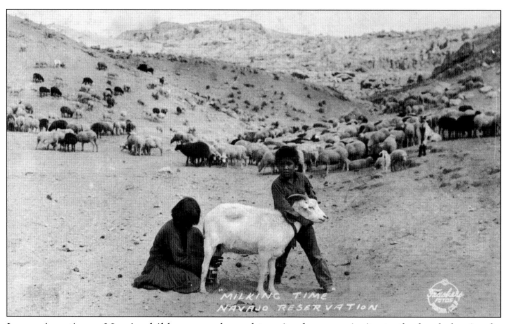

"MILKING TIME"
NAVAJO RESERVATION

In previous times, Navajo children were brought up in close proximity to the herded animals. In this early 1930s image, a Navajo boy and girl are engaged in milking a goat.

Mutton has long been a staple of the Navajo diet. In this view from about 1950, a Navajo woman is butchering a sheep; as part of her education, her daughter observes.

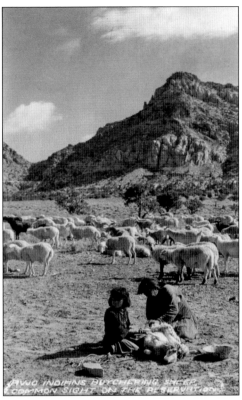

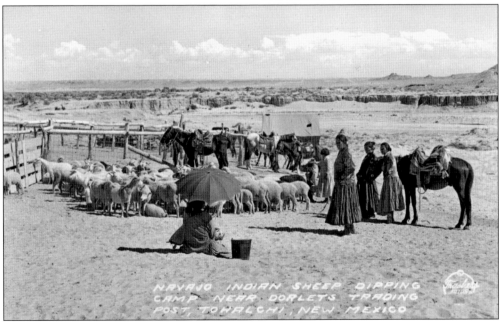

The value of dipping and vaccinating the sheep herds became an important part of Navajo animal husbandry practices in the first half of the 20th century. Often dipping stations were located at the trading posts, which required collecting of the animals and driving the herd several miles to the dipping vat.

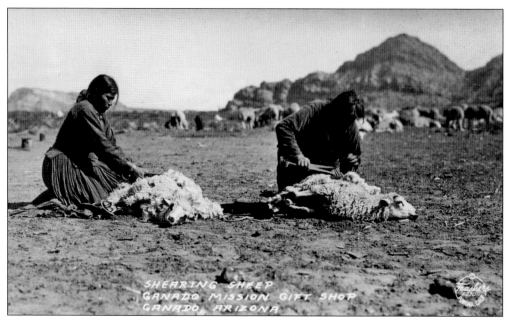

The process of weaving rugs from sheep's wool, a craft for which Navajo women are world renowned, begins with the catching and shearing of sheep. In this 1940s image, sheep are being sheared with commercially obtained shears. Shearing was typically done in the spring or fall.

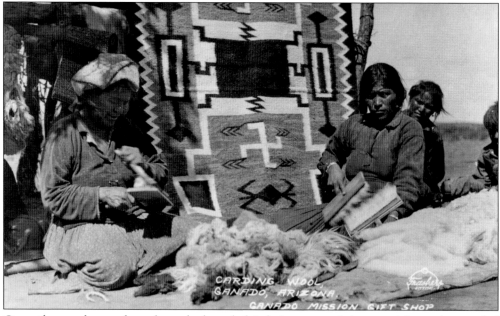

Once the wool was cleaned, washed, and dried, it was carded to straighten the tangled individual fibers into somewhat longitudinal strands. In this view, two Navajo ladies are using commercial carders to process the raw wool.

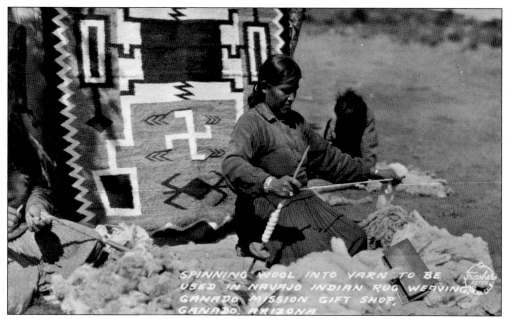

After the carding was finished, the loose fiber was reduced to a strand, a process achieved by pulling and twisting the fiber in one operation. The Navajo spindle consists of a wooden shaft with a wooden disk slipped over it. The wool may be respun two or three times until the desired thickness and tightness of the yarn is achieved.

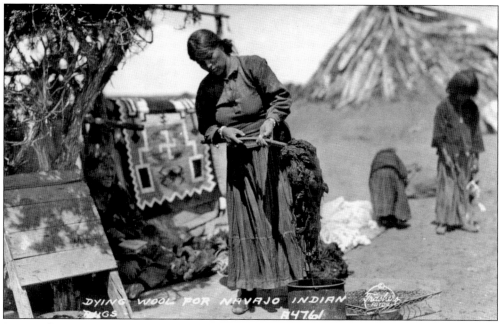

Regional patterns and colors characterize weaving in different parts of the Navajo Reservation. One of the distinctive differences is the source and color of dye materials. Wools could be colored by mixing the natural shades, use of dyes from various wild vegetable sources, and by using commercial dyes.

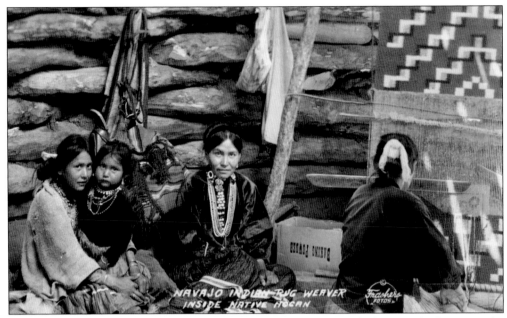

Navajo rug weaving is done on a vertical loom with a wood-pole frame. The loom can be rigged outside in the open, shade, or in the hogan. Traditionally Navajo-woven textiles also provided men's and women's clothing, saddle blankets, and other minor clothing articles.

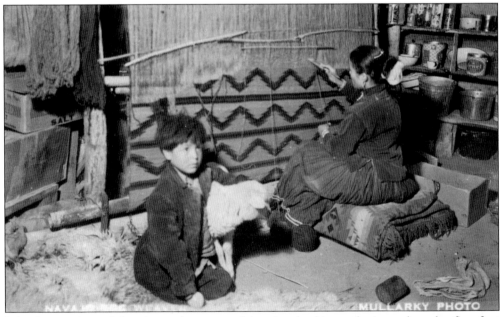

It has been estimated that the total amount of time involved in marketing a three-by-five-foot Navajo rug of average quality, from shearing the sheep to sale of the finished rug, can run about 350 hours in all. Approximately 60 percent of this time is spent in the actual weaving.

This early postcard view from about 1905 reflects the design, beauty, and symmetry of the Navajo rug. In this instance, the use of the "whirling logs" (swastika) element is apparent. It has been noted that the Navajo symbol pointed in a different direction from the later Nazi swastika. In this rug, however, it can be seen that the elements of these whirling log symbols in fact point in opposite directions.

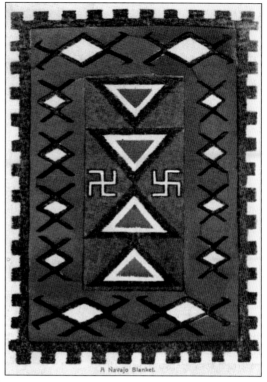

A Navajo Blanket.

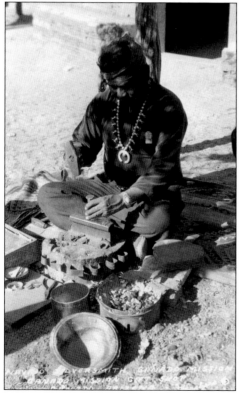

In addition to rugs, the Navajo are well known for their silver work, particularly incorporating silver with turquoise stones. In this 1940s image, the silversmith is shown with the tools of his trade—crucible and bellows, hammer, stamps, punches, and anvil (in this case a piece of railroad tie). He wears a hallmark of the trade—a squash blossom necklace.

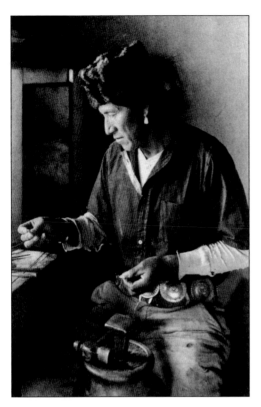

Here an unidentified Navajo silversmith is shown plying his trade in this postcard image by noted Southwestern photographer Laura Gilpin. The view was taken in 1934 and shows the artisan wearing a fur headband, common winter head wear.

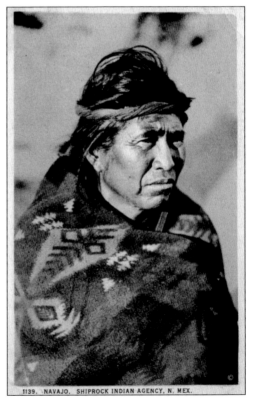

1139. NAVAJO. SHIPROCK INDIAN AGENCY, N. MEX.

As reflected by this image and those on the next several pages, Navajo people were a favorite subject for postcard views. This Navajo man was photographed in the early 1920s in the vicinity of the Shiprock Indian Agency, located at the northeastern corner of the reservation.

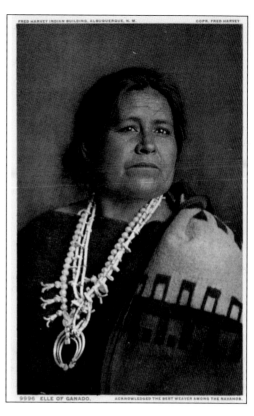

Elle of Ganado, Arizona, and her husband, Tom, were employed by the Fred Harvey Company from 1903 to 1924. Elle (*asdzaalichi*, or red woman) was advertised as "the best and most famous weaver among the Navajos" and was featured at Harvey Company hotels, particularly the Alvarado in Albuquerque. Tom was born to the Many Goats clan and was known as *Naaltsoos Neiyehe* (mail carrier), as he originally carried the mail between Gallup, New Mexico, and the Ganado Trading Post. Tom was a known storyteller and was fluent in the Navajo, Hopi, English, and Spanish languages.

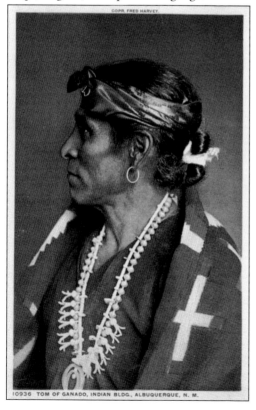

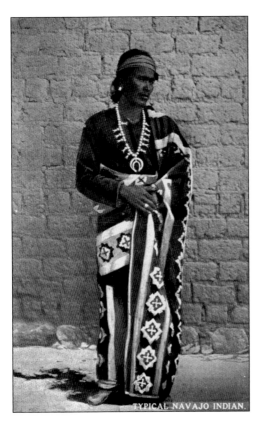

This image of a typical Navajo Indian man in traditional dress dates around 1920 and shows an exceptional example of the Navajo weaving style, worn in this case as a man's shoulder blanket. The man also wears a silver squash blossom necklace.

This impressive image of a young Navajo man named Pedro was published by the Fred Harvey Company and based on a 1906 photograph by the noted Southwestern photographer Karl E. Moon. Notable in this view are the traditional woven headband, hoop-and-ball earrings, and multi-strand shell and turquoise necklace.

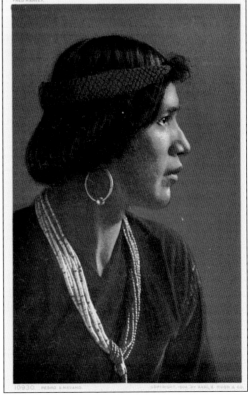

A young Navajo mother in traditional dress, including woven shawl, with a cradle and baby is shown in this early-1900s Fred Harvey image. Bound tightly to the cradle board, the canopy and cover are placed to provide needed shade for the youngster.

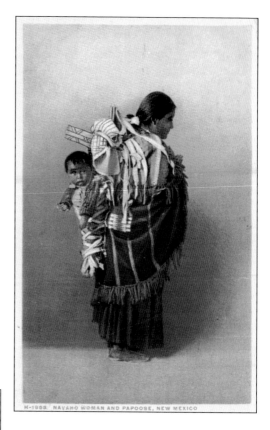

H-1953. NAVAHO WOMAN AND PAPOOSE, NEW MEXICO

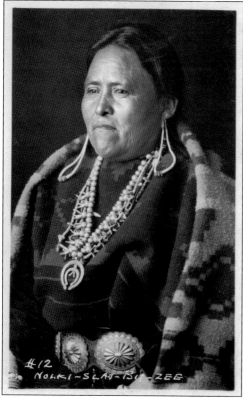

#12
NOLKI-SLAU-BU-ZEE

Nolki-slau-bit-zee, a Navajo lady, is shown in traditional attire and ornamentation. Accenting the woolen blanket dress are multiple turquoise and silver necklaces, a large silver concha belt, and *jackla* earrings.

23

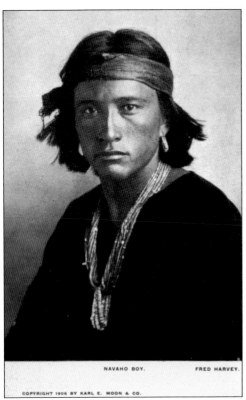

NAVAHO BOY.       FRED HARVEY.

COPYRIGHT 1906 BY KARL E. MOON & CO.

In a striking pose entitled "Navajo Boy," early photographer Karl E. Moon captured the essence of the Navajo male physique. This photograph was copyrighted in 1906 and published as a postcard by the Fred Harvey Company.

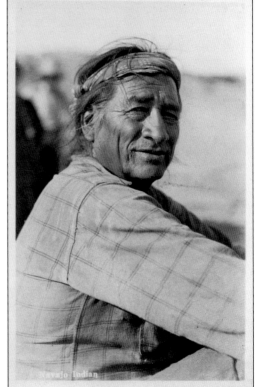

A dignified Navajo elder dressed in Anglo clothing is shown in this photographic postcard, published by the Union Pacific Overland Railroad in the 1920s or 1930s.

24

This 1940s postcard view of a young Navajo lady shows her ornamentation with turquoise earrings, a turquoise and shell necklace, and a velveteen blouse embellished with silver coin buttons.

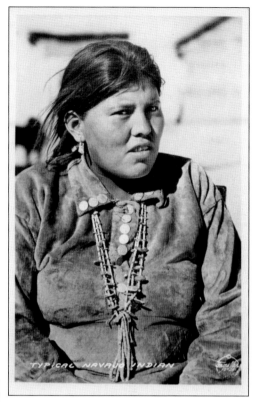

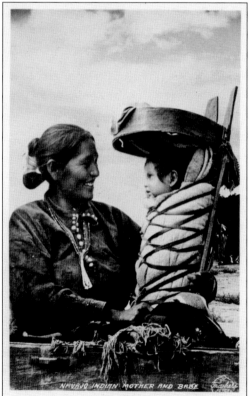

A glowing Navajo mother is reflected in this 1930s image. The youngster is bound in the traditional wooden, split-back cradle with canopy.

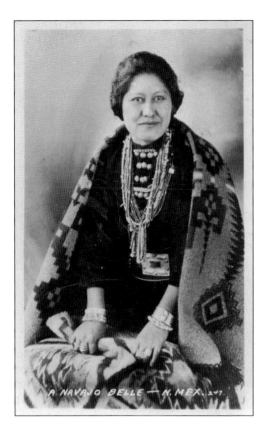

This postcard image, mailed in 1931, indicates the importance of jewelry to the Navajo woman. Included in her personal ornamentation are multiple silver and turquoise rings and bracelets; multi-strand necklaces of shell, coral, and turquoise beads; and silver buttons and pins.

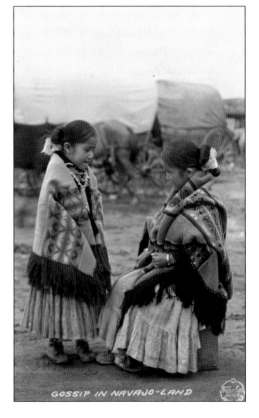

Two young Navajo girls are shown in this 1940s view, complete with traditional dress, jewelry, hairstyle, and store-bought Pendleton shawls. Wagons in the background indicate a camp near a town or trading post.

In the traditional Navajo religious system, ceremonies and rites are led by trained practitioners called "singers." Singers acquire their specialized knowledge through an apprenticeship process, which often spans years. These practitioners possess the knowledge of ritual that can control dangerous things, exorcise ghosts, restore universal harmony, and sometimes cope with witchcraft in the society. Their knowledge frequently includes hundreds of songs, prayers, myths, designs for sandpainting, and associated herbal medicine for each chant or ceremonial event they are familiar with. Since each of the chants is complex, lengthy, and requires considerable knowledge, most singers only specialize in one or two ceremonies.

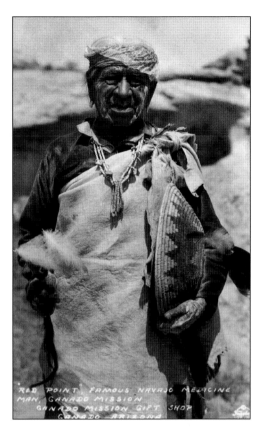

RED POINT, FAMOUS NAVAJO MEDICINE MAN, GANADO MISSION. GANADO MISSION GIFT SHOP, GANADO, ARIZONA

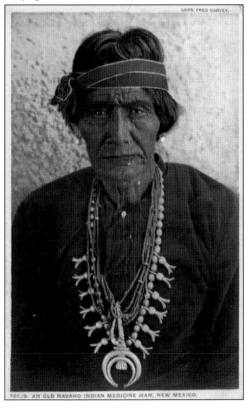

COPR. FRED HARVEY.

70605- AN OLD NAVAHO INDIAN MEDICINE MAN, NEW MEXICO.

A group of Navajo men is shown in this 1930s image. Anglo clothing, footwear, and hats prevail, along with the traditional hairstyle. Both men and women used the same type of hair tie, with the men adding a headband of buckskin or cloth.

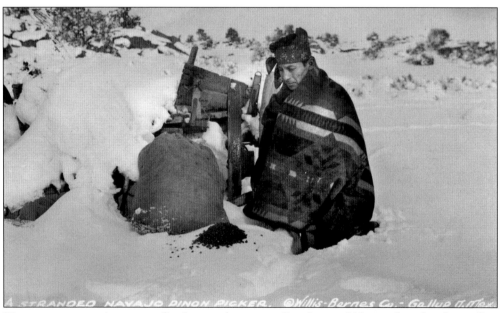

Pinon nuts were an important diet item and a commodity that could be marketed at the trading post. Nut gathering had to be carefully calculated, as an early snowfall could interfere with the process as indicated in this early-1930s view of a stranded Navajo nut picker.

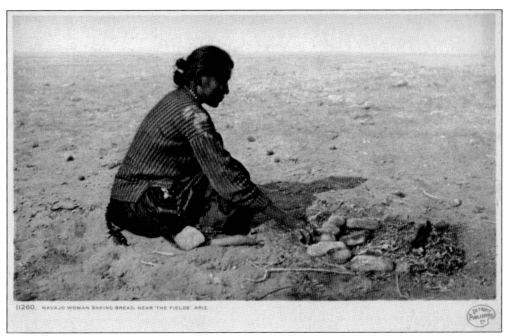

This view from about 1915 shows a Navajo woman cooking bread over an open fire. In earlier times, wafer or fried bread was cooked on a shaped, stone griddle that rested on stones, raising it three or four inches above a bed of hot coals.

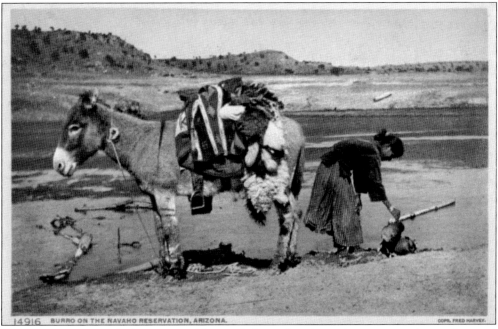

Prior to about 1940, baskets covered by pitch from the pinon pine were used to collect and transport water for household use. In this Fred Harvey image mailed in 1913, a young Navajo woman is shown getting water, along with her mode of transportation.

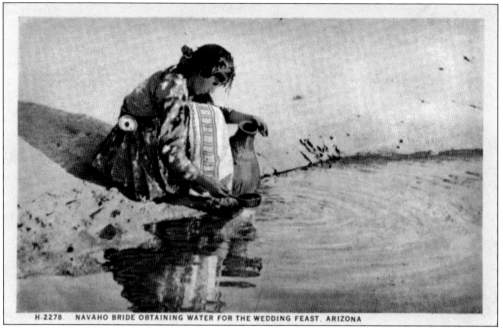

H-2278. NAVAHO BRIDE OBTAINING WATER FOR THE WEDDING FEAST, ARIZONA

Water is an important component of the marriage ceremony for bathing, the ritual washing of hands, and the preparation of cornmeal porridge. In this Fred Harvey image from about 1915, the prospective bride is ladling water into a pinon-pitched basketry water bottle.

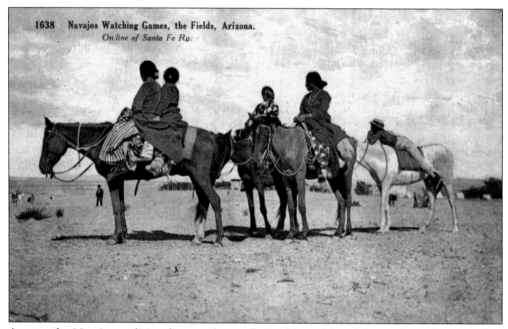

1638  Navajos Watching Games, the Fields, Arizona.
On line of Santa Fe Ry.

Among the Navajo, traditional games have relationships with origin myths and ceremonies. Races and other games of chance were also played to occupy intervals of time between elements of multiday ceremonies. Permissible near or on the ceremonial grounds, games also offered an opportunity for spectators.

30

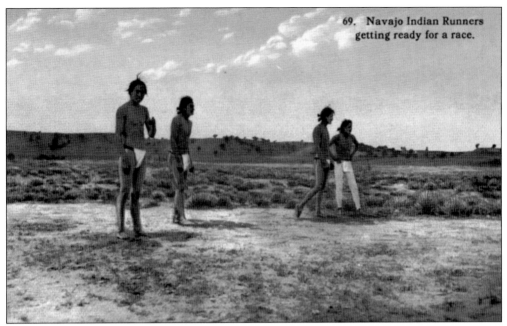

69. Navajo Indian Runners getting ready for a race.

Historically, Navajo men stripped off their clothing and ran to a predetermined point, a quarter mile or farther, and perhaps back. Foot races also played an important part in several of the Navajo religious narratives and were held between ceremonial rituals.

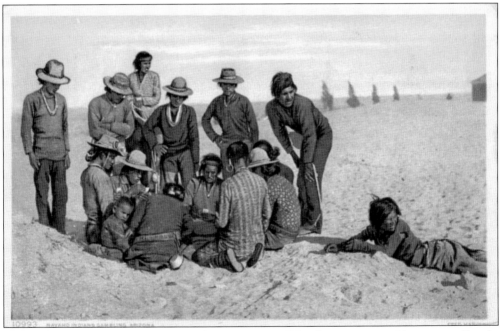

This early-1920s Fred Harvey image shows a group of Navajo men engaged in a game of cards. In the absence of currency, wooden matchsticks were sometimes used as gaming tokens.

31

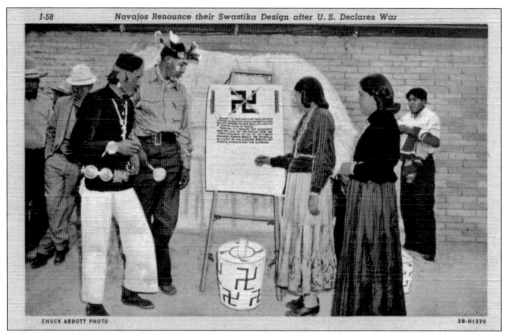

CHUCK ABBOTT PHOTO　　　　　　　　　　　　　　　　　　　　　　　　　3B-H1370

At the outbreak of World War II, the Navajos formally renounced the use of the "whirling logs" or the swastika symbol, believing Nazi Germany had desecrated it. Previously, the symbol had been one of friendship and was used to decorate blankets and rugs, baskets, silverwork, sandpaintings, and clothing.

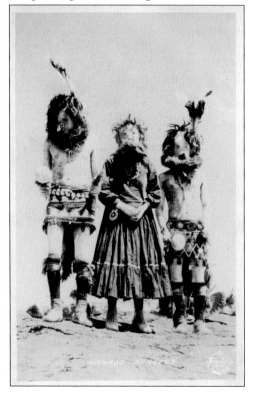

*Yeibichai* dancers perform at the major winter curing ceremony known as the Night Chant or Nightway. A group of three masked impersonators of the *Yei*, a class of supernatural beings, also participate in the Fire Dance, including the leader, Talking God; a granduncle or maternal grandfather; and a Female God, as shown in this late-1920s image.

The Navajo Fire or Corral Dance is one of the dances performed during the nine-day healing ceremony known as the "Mountainway Chant." In this dance, the participants perform around a large bonfire within a corral made of branches.

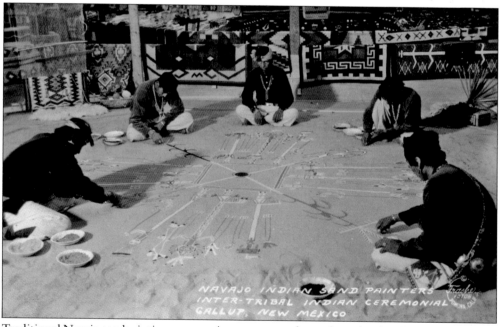

Traditional Navajo sandpaintings serve as impermanent altars where ritual actions are performed in the ceremonial context. They are exact pictorial representations of the supernatural setting and are essential parts of the curing process. At the end of the ritual, they are always destroyed.

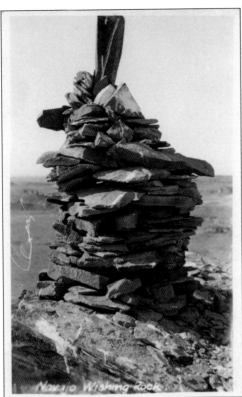

Trail shrines where stones were repeatedly placed, also known as wishing piles or prayer piles, are found throughout Navajo country along routes of travel. This image from about 1920 shows one of these rock cairns.

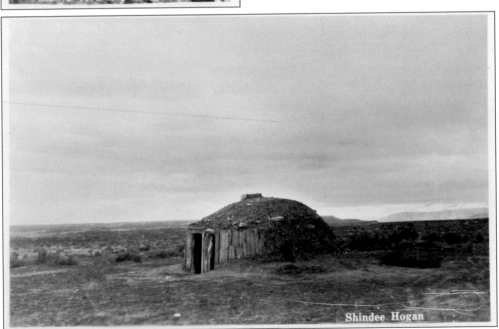

Because of a fear of ghosts, traditional Navajos would abandon a hogan if a death occurred within. A death hogan is popularly known as a *chindi* hogan, and a hole might be broken or chopped through the northern side to remove the body, as can be seen in this *c.* 1930 view of a *chindi* hogan.

# *Two*

# HOPI

The Hopi Reservation is located in northeastern Arizona, bounded on all sides by the Navajo Nation. Steep mesas and valley terrain characterize the northern part of the approximately 2,440-square-mile reservation. The southern part is composed of wide, rolling valleys and semi-desert grasslands. The reservation was originally set aside for the Hopi people by executive order in 1882. At present, most of the more than 7,000 Hopis live in several villages situated on and around three, fingerlike mesas extending from Black Mesa to the north, with another village located about 40 miles to the west near Tuba City. One of these villages, Old Oraibi on Third Mesa, was built at least as early as 1550 and is considered one of the oldest continuously occupied cities in the United States.

The Hopi, also referred to early on as the Moki or Moqui, were subjected to missionary activities in the 1600s when the Franciscans established missions in several of the villages, but long-lasting Spanish influence was never maintained. Thus, the Hopis remained somewhat isolated and practiced their own religious and political life into much of the 20th century. Between 1894 and 1912, schools were established near the Hopi villages, and in 1913, a government hospital was opened at Keams Canyon on the east side of the reservation.

The Hopi have always relied upon an agricultural economy, supported by the raising of livestock acquired from the Spanish. In recent years, craft arts have provided a growing source of income for many Hopis. No other Southwestern tribe produces a greater variety of crafts than the Hopi, including beautiful pottery, katsina (kachina) dolls, weaving, distinctive silverwork, and three types of basketry.

Hopi ceremonial dances, masked and unmasked, are impressive and include dramatized prayers for rain, the growth of crops, renewal of the cycle of life, and well-being of all people and all living beings. Initially open to outside visitors, indiscretions by guests have caused many of the villages to close their ceremonies to non-Hopi in recent years.

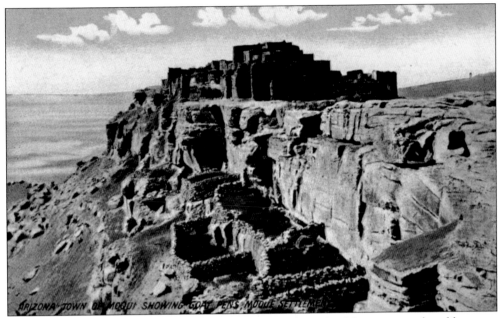

ARIZONA TOWN OF MOQUI SHOWING GOAT PENS MOQUI SETTLEMENT

This view of the historic Hopi village of Walpi, located on First Mesa, was produced between 1907 and 1914. It was established in 1690 when a village at the foot of the mesa was abandoned out of fear of Spanish reprisals for the 1680 Pueblo Revolt. Since that time, the village has been continuously occupied.

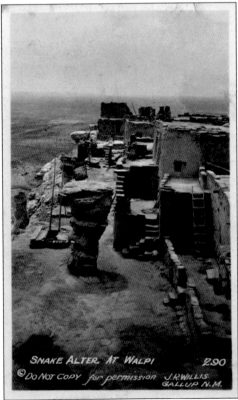

SNAKE ALTER AT WALPI          2.90
©Do Not Copy for permission  J.R.WILLIS
GALLUP N.M.

The main dance plaza at Walpi can be seen in the foreground of this postcard image, mailed in 1929. The ladder entrance to a *kiva*, or underground ceremonial room, is visible just to the left of the rock pillar. Multistory masonry habitation rooms make up the village.

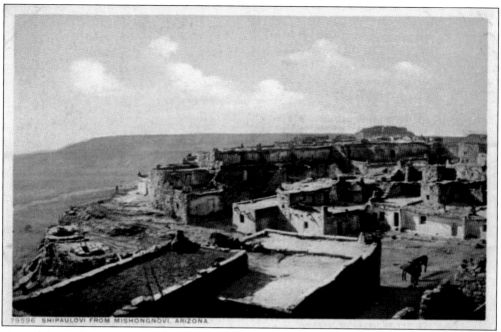

One of the multistory villages located on the middle or Second Mesa of the three Hopi mesas is Shipaulovi, shown in a Fred Harvey image from about 1915. Two kiva entrances can be seen near the cliff's edge at the left center of the view.

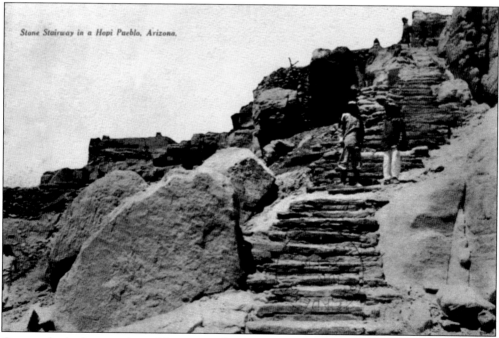

One method of approach to this unnamed, mesa-top Hopi village was via a well-constructed stairway. The postcard was published by Fred Harvey and postmarked in 1908.

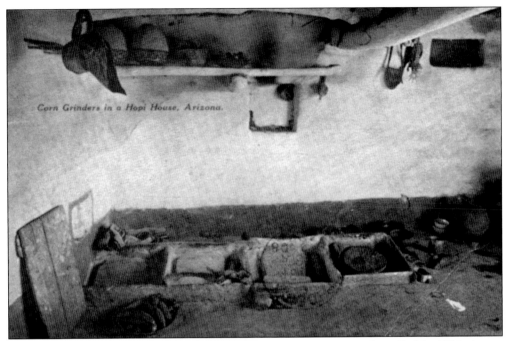

The interior of a Hopi house is shown in this early Fred Harvey card, mailed in 1908. A row of mealing bins for grinding corn rests on the floor, while other household items line a wall shelf above.

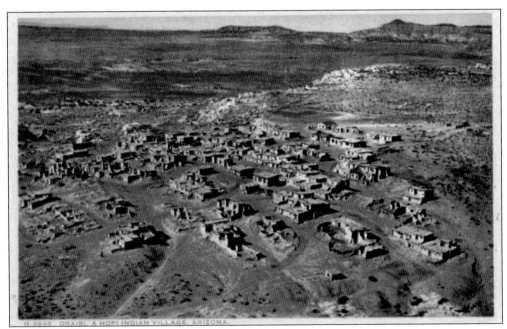

An aerial view of the Third Mesa Hopi village of Oraibi is shown in this Fred Harvey view from about 1915. In 1629, the Spanish established the mission of San Francisco at Oraibi. The mission ruins lie north of the village.

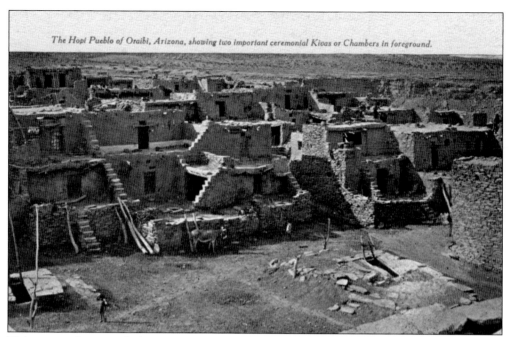

*The Hopi Pueblo of Oraibi, Arizona, showing two important ceremonial Kivas or Chambers in foreground.*

This postcard, printed about 1908, provides a close-up view of the multistoried village of Oraibi. At times in the past, some areas of the village reached four stories in height. Two kiva entryways can be seen in the foreground.

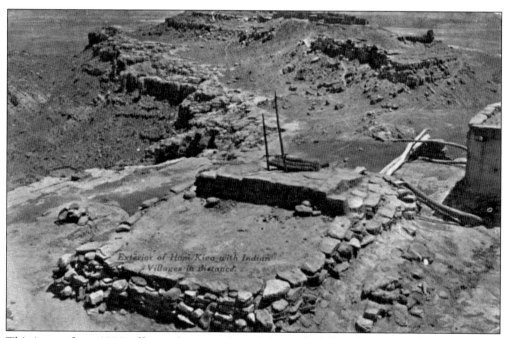

*Exterior of Hopi Kiva with Indian Villages in distance.*

This image from 1908 offers a close-up view of the roof of the subterranean kiva ceremonial room. The entry ladder is visible to the rear of the structure. The village is unnamed on the card, but the image is probably from Oraibi.

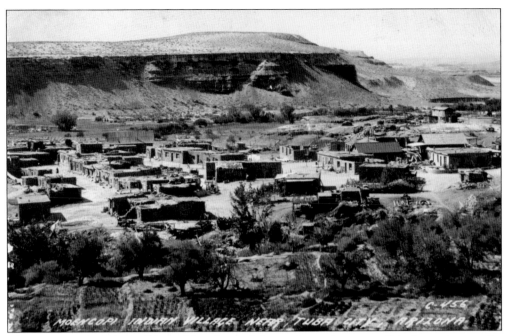

The westernmost Hopi village, Moenkopi, "place of running water," is located near the Navajo Reservation town of Tuba City, about 40 miles from Oraibi. It was originally a farming settlement associated with Oraibi but was established as a separate village in the 1870s. Moenkopi is the only Hopi village with irrigated fields.

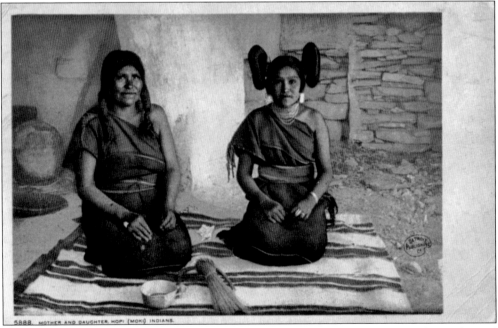

This *c.* 1905 postcard pictures a Hopi mother and daughter, both clothed in the traditional *kwasha*, or woven everyday dress with a narrow belt. A hairbrush made of grass stems lies on the blanket between the two women. The brush also doubled as a broom for the household floor and mealing bins.

The Hopi maiden in this image was photographed by Edward Curtis, probably in 1900, and shows the girl in the traditional, unmarried hairstyle, with a woven dress and maiden's shawl. The postcard was postmarked in 1905.

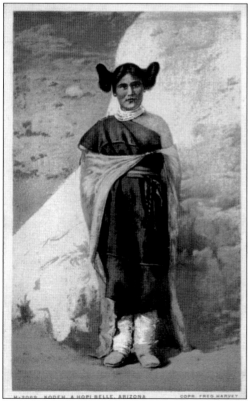

An unmarried Hopi maiden by the name of Kodeh is pictured in traditional attire in this Fred Harvey postcard published about 1915.

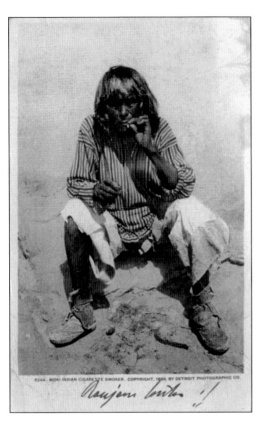

This postcard view of a Hopi man smoking a cigarette was published in 1899 by the Detroit Photographic Company. The type of cigarette cannot be determined. Making cigarettes from wild tobacco and reed stems predates the arrival of non–Native Americans into the Southwest.

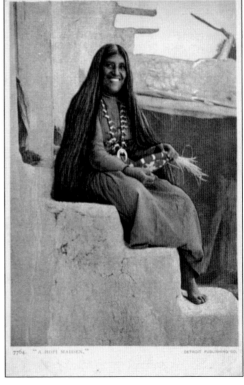

In this pre-1905 view, a Hopi maiden with her hair down wears a squash blossom silver and coral necklace of Navajo origin. The unfinished coiled basket in her hands identifies her as being from a Second Mesa village where this type was woven.

This postcard image, produced around 1910, is titled, "Hopi courtship, Pueblo of Shumopavi." This village is located on Second Mesa. The Franciscan mission of San Bartolome was built at a former location of this village in 1629, but was destroyed during the 1680 Pueblo Revolt against the Spanish.

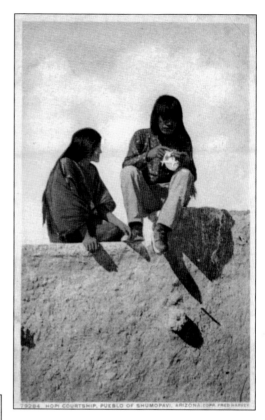

79284. HOPI COURTSHIP, PUEBLO OF SHUMOPAVI, ARIZONA. COPR. FRED HARVEY

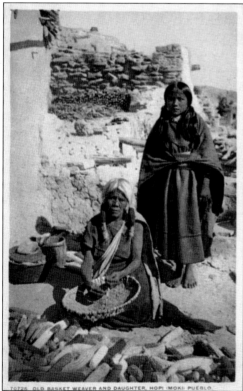

70725. OLD BASKET WEAVER AND DAUGHTER, HOPI (MOKI) PUEBLO.

A Hopi mother and daughter are shown in this image, printed around 1910, and are clearly involved in processing and storing the recent corn harvest. The mother holds a plaited basket made of yucca leaves. This style of basketry was made by villagers at all three mesas.

43

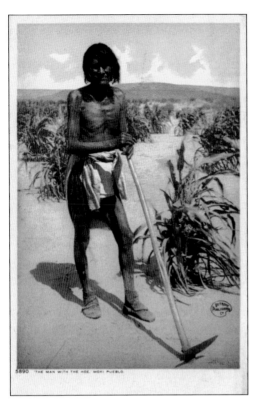

This early view from about 1900 shows a Hopi man in his corn field. Hopi corn fields are located at some distance from the villages and placed in sand dune fields to take advantage of scarce moisture. Having traditionally relied on corn as a foodstuff, a significant aspect of summer ceremonials is directed at ensuring rainfall.

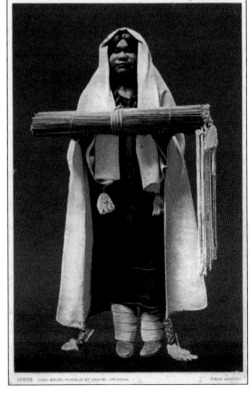

At the time of marriage, the Hopi maiden was dressed in a white bridal robe woven by the male relatives of her groom. The wedding ensemble was presented to her at her mother-in-law's house, including the rolled-reed suitcase that contains a smaller robe and broad, white belt.

A Hopi boy is shown in this Fred Harvey card from about 1915. Hopi boys are taught about the ceremonial aspect of Hopi life at an early age, but are not permitted to formally take part until initiated into a kiva society.

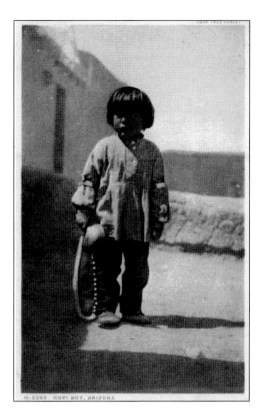

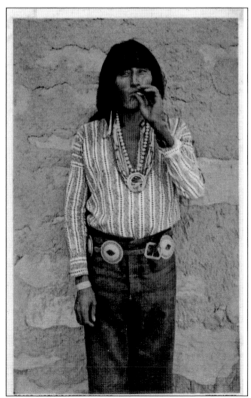

This Hopi man has the traditional men's haircut but is shown wearing Anglo-style clothing, along with a Navajo-made silver concha belt and silver necklace. The image was published by the Fred Harvey Company about 1915.

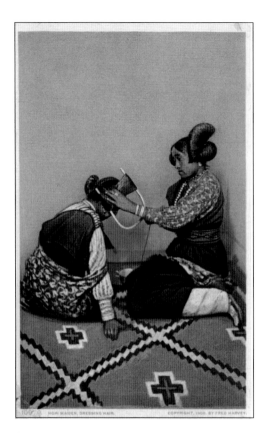

In this Fred Harvey postcard image (copyright 1908), two unmarried Hopi girls are shown dressing their hair in coils or whorls. Later, as married women, their hair will be worn in two braids which fall over their shoulders in front.

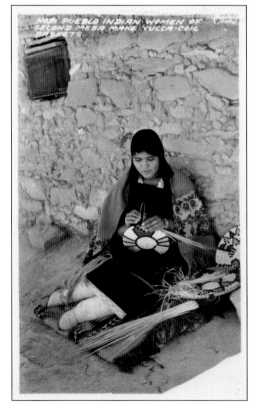

This Second Mesa village image shows a Hopi woman who is engaged in the making of the tightly woven coiled basketry plaques. Grass coils are sewn with narrow strips of dyed yucca leaves. Second Mesa villagers have followed the art of coiled basketry for over 100 years.

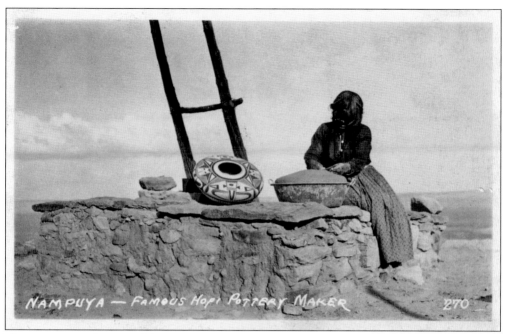

NAMPUYA — FAMOUS HOPI POTTERY MAKER 270

Nampeyo, most famous of the Hopi potters in the early 1900s, was born around 1860 in the First Mesa village of Hano. She is credited with being an innovator in shape and design, bringing back old designs from ancient ruins in the vicinity of the Hopi villages. Nampeyo and her family lived at the replicated Hopi House at Grand Canyon National Park in 1905–1906 and were transported to the Chicago Exposition by the Fred Harvey Company and Santa Fe Railway in 1910 to demonstrate her pottery skills. By 1920, Nampeyo's eyesight had deteriorated, and while she continued to construct pottery vessels into the late 1930s, much of the later pottery was painted by others, including her daughter, Fannie. Nampeyo died in 1942, and she was elected to the Arizona Women's Hall of Fame in 1986.

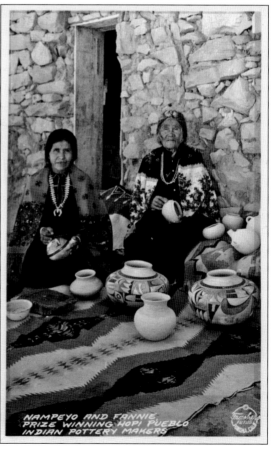

NAMPEYO AND FANNIE
PRIZE WINNING HOPI PUEBLO
INDIAN POTTERY MAKERS

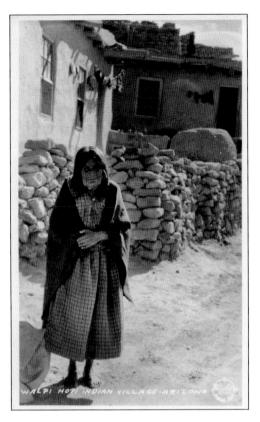

This image, probably from about 1930, shows a Hopi elder in her First Mesa village of Walpi. Her dress is made of commercial cloth, but her shawl appears to be the traditional woven cloth. It was customary for Hopi women and children to go barefoot in the milder months of the year.

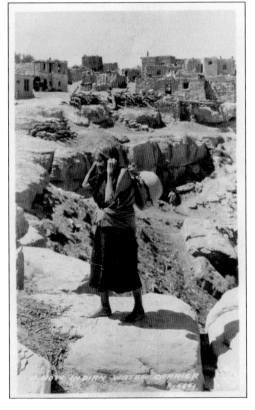

Carrying water to the villages was a way of life for the Hopi, since their villages were situated on mesa tops without obvious water sources. In this view from the 1920s, a woman is hauling water in a large pottery canteen. Piles of firewood, also transported from below, can be seen in the background.

This postcard features an elderly Hopi couple in an unnamed village in the 1930s. She is dressed in the traditional woman's dress and shawl with moccasins, while he is primarily dressed in Anglo-style clothing, along with headband, shell necklace, and silver concha belt.

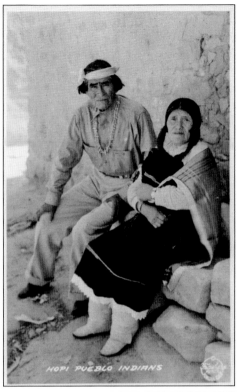

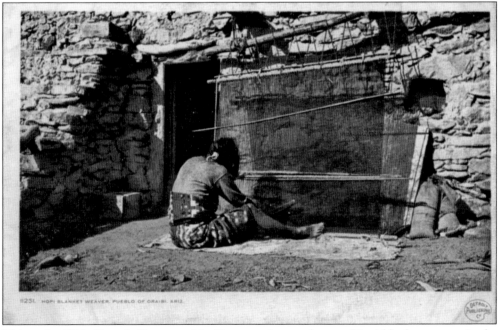

This early-1900s Detroit Photographic Company image shows a Hopi blanket weaver in the Third Mesa village of Oraibi. Among the Hopi, men were responsible for spinning the cotton yarn and weaving items for the village, including women's clothing. Two types of looms were used, an upright loom for wide fabrics and a smaller, horizontal one for belts.

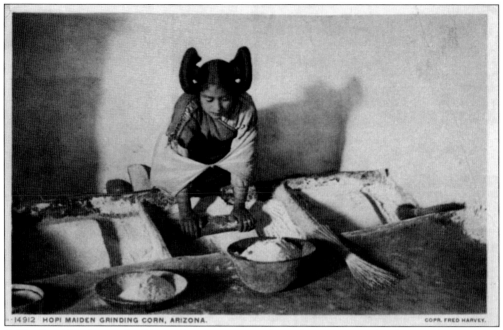

A Hopi maiden is seen in this Fred Harvey image from about 1915 in the then daily process of grinding cornmeal with a flat stone. After grinding, the meal was stored in pottery and basket containers. A grass broom is visible for cleaning the mealing bin.

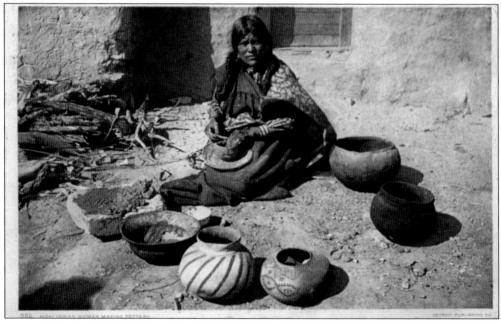

This image from the 1890s shows a Hopi woman shaping pottery from clay that has been ground on the flat stone and mixed with water. Finished vessels, including both decorated and undecorated forms in various shapes, are evident.

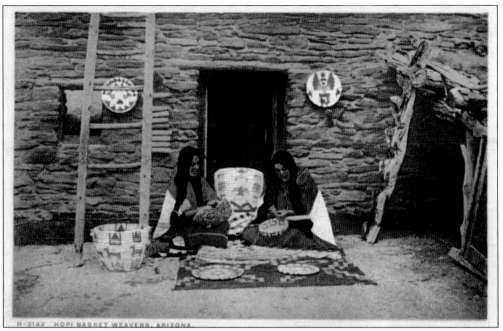

This early Fred Harvey image shows two Hopi women weaving baskets in an unnamed village. Because of the coiled baskets being produced, the scene can be attributed to one of the Second Mesa villages. Both plaque and deep container baskets are being woven.

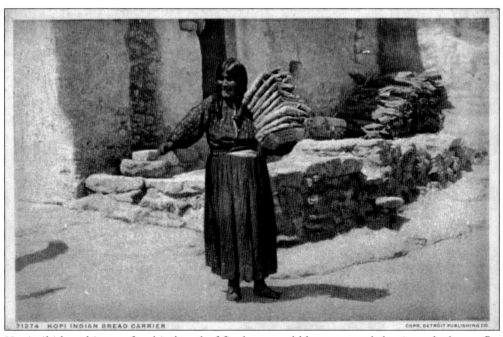

Hopi piki bread is a wafer-thin bread of finely ground blue cornmeal that is cooked on a flat stone. After cooking, it is peeled off the stone and folded into squares or rolled up. Prepared before all ceremonies, it was an item of daily consumption in earlier times.

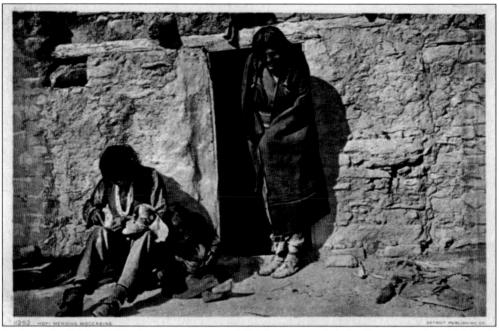

In the early 1900s, all Hopi men, women, and children wore plain leather moccasins. Although they were eventually replaced by commercially manufactured shoes, moccasins have been retained for ceremonial use.

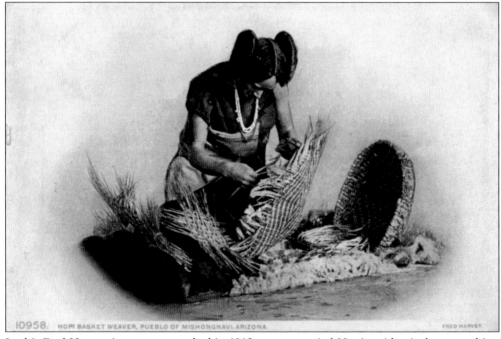

In this Fred Harvey image, postmarked in 1912, an unmarried Hopi maiden is shown making a plaited basketry mat of green yucca leaves. A wooden ring is added to make the Hopi sifter, or ring basket, an all-purpose utility vessel. A finished basket is at the right.

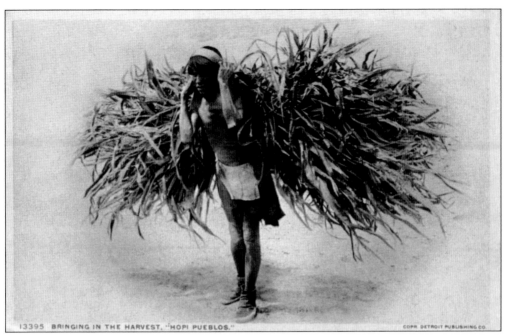

Hopis traditionally planted several varieties of corn, classified by color, in the distant fields. Most of the corn was harvested in the month of October and hauled to the village in this manner before wagons and trucks became popular.

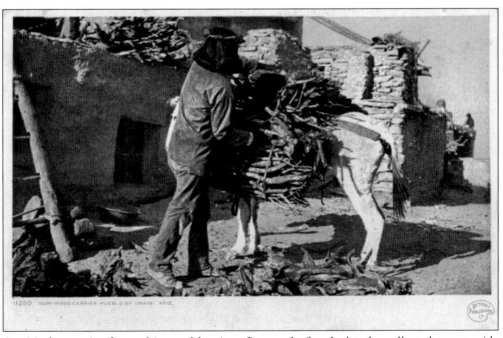

A critical necessity for cooking and heating, firewood often had to be collected over a wide area and transported to the village. In this view from the village of Oraibi, the wood hauler uses a burro to carry the load.

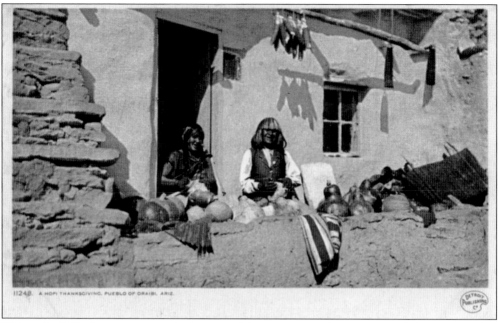

This early-1900s image portrays the bounty of the Hopi agricultural economy. Ears of corn can be seen hanging from the pole above, while several types of pumpkins and squash are evident. A large burden basket, used to transport the harvest yield lies at right center.

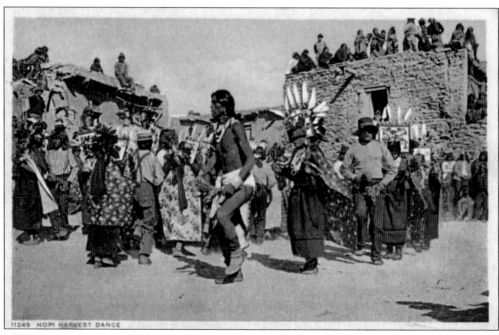

Three unmasked dances occur in the fall months at the Hopi villages and are performed by the women's societies. One of these, put on by the Lakon Society, is performed to coincide with corn-harvesting time in late September and early October.

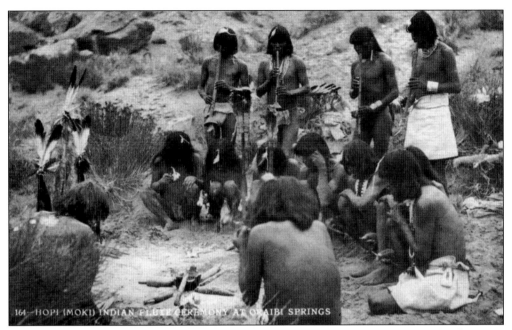

164—HOPI (MOKI) INDIAN FLUTE CEREMONY AT ORAIBI SPRINGS

The Flute Ceremony is performed biennially by the two Hopi flute societies to aid in bringing late summer rains that are needed for the crops to reach full maturity. In this early image, members of the flute society bless the village spring at Oraibi.

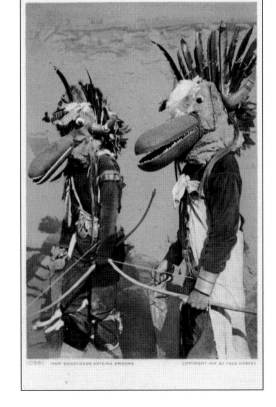

Among the many masked katsinas recognized by the Hopi are the *Soyoko*, or ogre. The *Soyoko* pair shown in this 1908 Fred Harvey image function to frighten children into proper behavior by threatening to carry off disobedient youngsters. The parents often must ransom the children with food offerings.

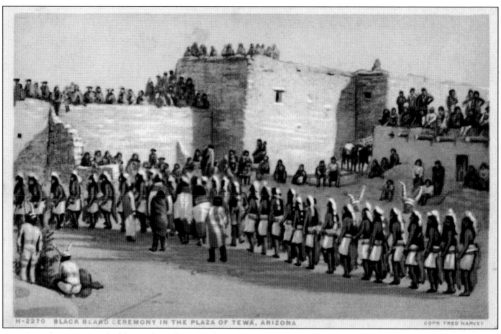

Katsina dances are held in the plazas of the villages. In this Fred Harvey image from about 1915, a group of *Angak'chinas*, or Longhaired Katsinas, is shown in the village of Hano on First Mesa. The function of this ceremony is to produce rain and secure abundant crops.

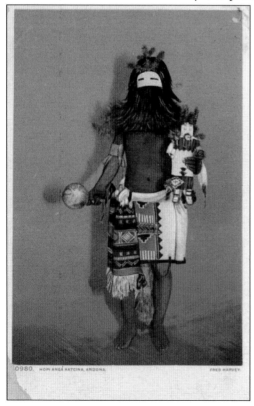

This Fred Harvey image offers a close-up view of a Longhaired Katsina, in this instance the *Katoch Angak'china*, or barefooted Longhaired Katsina. The traditional katsina woven dance kilt and sash form the ceremonial clothing. The katsina doll held in the left hand will be given out during the dance.

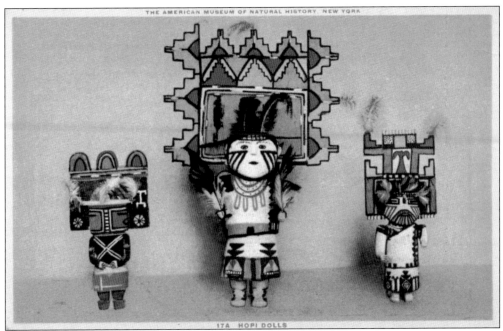

17A HOPI DOLLS

Painted, carved, wooden katsina figurines are used in the religious training of young Hopi children. Children and women receive the dolls as gifts or blessings from the masked dancers who appear in the village during katsina ceremonies. In the past 50 years or so, finely carved katsina figurines have become a significant craft art for Hopi artisans.

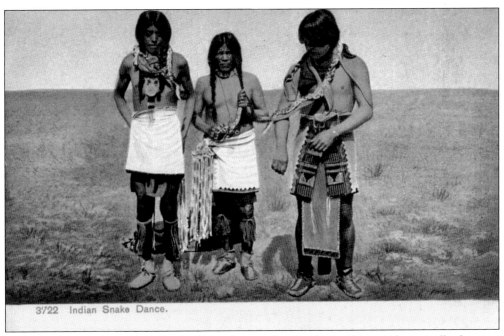

3722 Indian Snake Dance.

Although a minor ceremony for the Hopi, the non-katsina Snake Dance is historically the most widely known of all Hopi ceremonies. The gathering of the snakes by the snake men, depicted in this postcard view from about 1907, begins several days before the public performance.

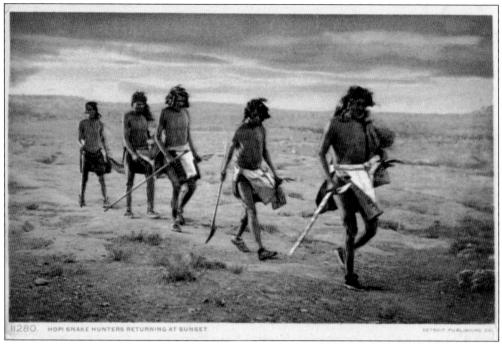

Four days are spent in the snake hunting—one in each of the cardinal directions. All snakes encountered, poisonous and non-poisonous, are blessed and gathered. This Detroit Publishing Company image, produced about 1910, portrays the Hopi snake hunters returning to the village at sunset.

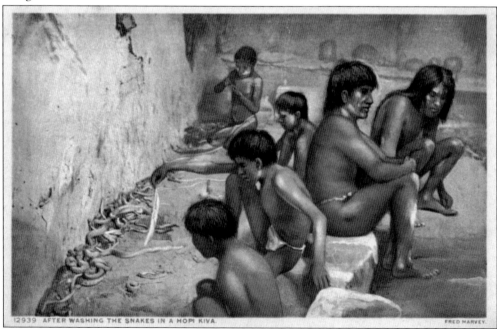

On the ninth and last day of the ceremony, the snakes are taken to the snake kiva where they are carefully tended. All the reptiles are washed and purified while the priests smoke and pray over them.

The Hopi Snake Priest is in charge of all activities associated with the nine-day event. In this striking image, produced about 1905, a priest named Taqui is featured in traditional Snake Dance attire and ornamentation, including a silver Navajo necklace.

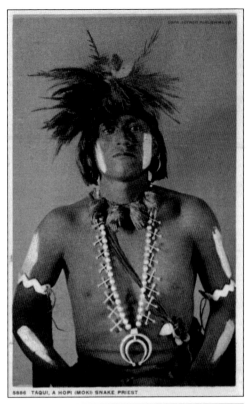

5886 TAQUI, A HOPI (MOKI) SNAKE PRIEST

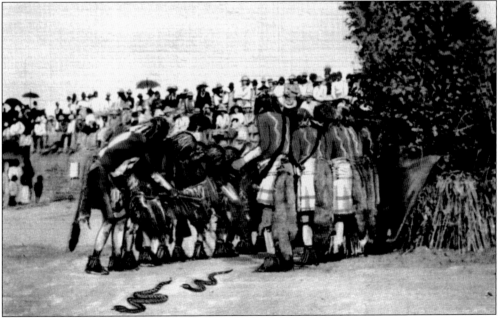

The Hopi Snake Dance itself is the late August culmination of a nine-day private Snake-Antelope ceremony to bring rain and good health. Snakes—creatures also in need of rain in the arid desert climate—are spirit messengers. This 1920s view shows the Snake and Antelope dancers in two rows of 12 men facing each other in the village plaza.

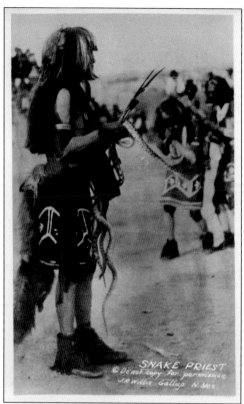

On the final day of the Snake Dance, the dancers perform while holding live snakes in their hands and mouths. Afterward, the snakes are set free far from the village in sacred places situated at the four Hopi cardinal directions.

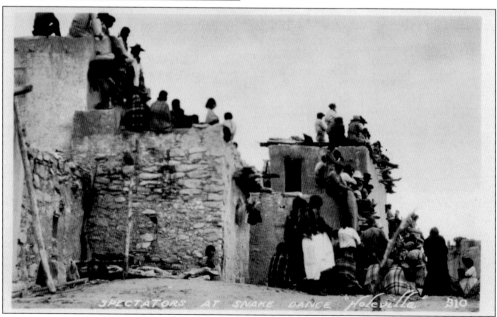

The Snake Dance was a popular ceremony not only for the Hopi but also for neighboring Navajos and Anglo visitors, many of whom traveled great distances to view the spectacular ritual event. This image shows Snake Dance spectators at the Third Mesa village of Hotevilla about 1930.

# *Three*

# WESTERN APACHE
# AND YAVAPAI

While unrelated culturally and linguistically, the Western Apache and Yavapai people share a similar geographic setting. The Yavapais are located in the central upland areas of Arizona, while the Western Apaches are situated in the east-central mountainous regions. The two groups also share a common post-contract bond dating to the latter part of the 19th century when the federal government sought to gather together the then numerous Apache and Yavapai bands on a single reservation—today's San Carlos Apache Reservation. This experiment began in the mid-1870s, but by the end of the century, the Yavapais and non–San Carlos Apaches were permitted to return to the vicinity of their former homelands.

Today the Yavapais are located on three, separate reservations: Camp Verde Yavapai Reservation (established in 1871, abandoned, then reestablished in 1909), Yavapai-Prescott Reservation (established 1935), and the Fort McDowell Yavapai Nation (established 1903). In 2007, the Western Apaches are primarily found on three reservations in eastern Arizona: Tonto Apache Reservation (established in 1974), Fort Apache Reservation (established in 1871 as the joint White Mountain–San Carlos Reservation, then partitioned as a separate reservation in 1897), and the San Carlos Reservation (established in 1871).

Yavapais did not practice agriculture but instead led a seminomadic existence, subsisting entirely by hunting and gathering wild foods. Dwellings were caves or rock shelters that sometimes had partial windbreaks as well as brush shelters similar to Apache wickiups. Sturdy and lightweight basketry was the most important kind of container used by the Yavapai. The sale of such baskets to tourists later became a significant source of money.

The Western Apache, once comprised of numerous independent bands, were spread over a large area of eastern Arizona. Another Apache grouping, the Chiricahua, historically occupied much of southeastern Arizona. While primarily nomadic people, the Western Apache learned agricultural techniques from neighboring tribes and depended on both cultivation and seasonal plant gathering and hunting. The introduction of the horse greatly expanded the range of the Western Apaches, allowing them to establish a widespread network of trade and raiding routes. This lifestyle continued until their forced relocation to reservations.

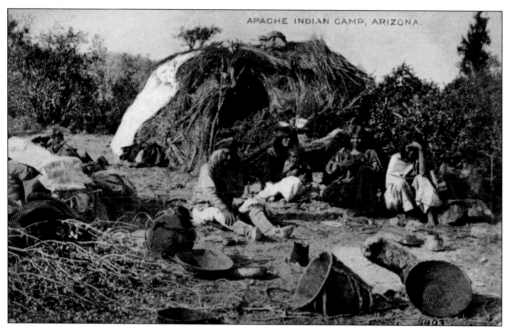

A late-1800s view shows a typical Western Apache family camp, probably in the vicinity of Globe, Arizona, on the San Carlos Reservation. The conical pole-and-brush wickiup served as the family dwelling. Canvas was sometimes used to partially cover the structure on the windward side.

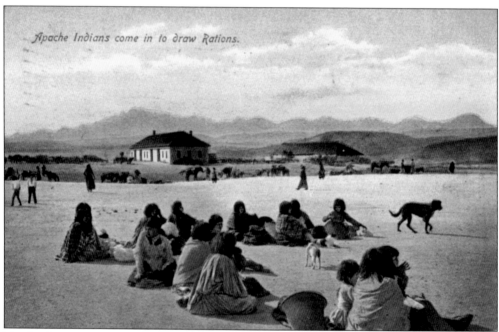

The Indian agency at the San Carlos Apache Reservation was established in 1873 to serve all Western Apache and Yavapai. Bands were brought to the agency from a wide area, resulting in a population of nearly 5,000. Rations of food and clothing were regularly issued to support the residents.

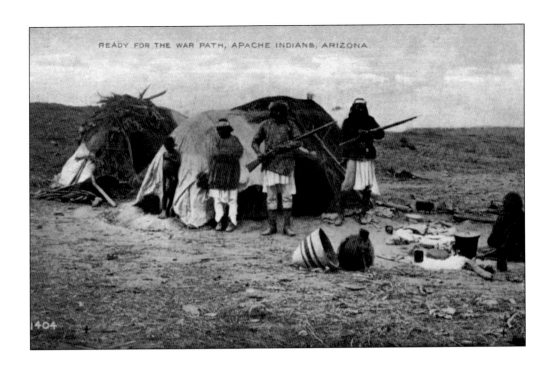

Because of the well-known and widely reported Apache wars of the late 1800s in Arizona and surrounding areas, postcards depicting Western Apaches continued the familiar illusion of the Apache warrior and his warlike tendencies well after 1900. Although defeated in battle, the Apache warriors were admired for their reputations as formidable foes for the U.S. Army.

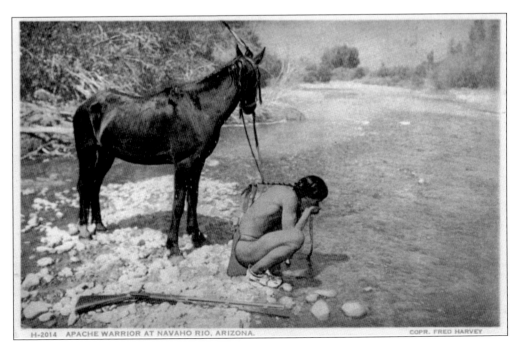

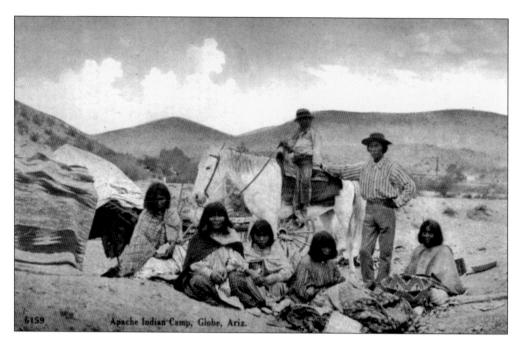

6159    Apache Indian Camp, Globe, Ariz.

These two early-1900s views of a Western Apache camp near Globe, Arizona, reflect a traditional lifeway but one in the process of transition. The home is still the customary wickiup, covered with canvas. Containers evident in the images incorporate a combination of traditional basketry, including the pitch-covered water bottle (*tus*) and metal items. The women all wear the "camp dress" made of commercial cloth, along with shawls, while the males are dressed in Anglo clothing. A wagon can be seen in the background. A woven rug of Navajo origin reflects the trading that was common between tribes.

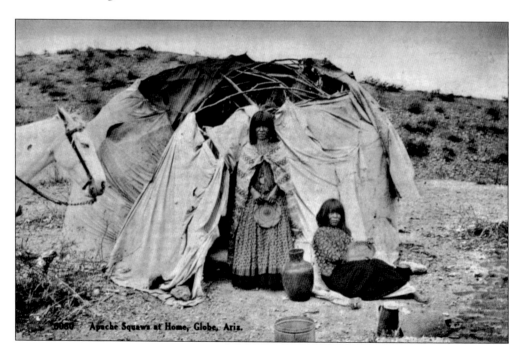

Apache Squaws at Home, Globe, Ariz.

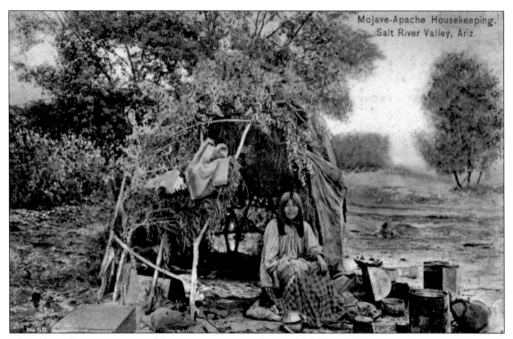

This view shows a comparable camp scene on the Fort McDowell Reservation, which housed primarily Yavapai people along with some Apaches. A traditional, domed brush house is present, but all cooking utensils, storage containers, and boxes are clearly Anglo in origin.

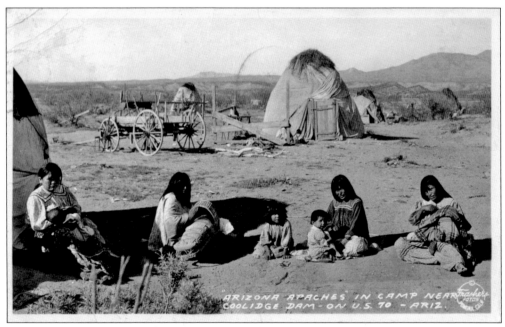

A typical, early-1940s Apache encampment is shown near Coolidge Dam on the San Carlos Apache Reservation. The traditional wickiup continued as the principal dwelling even at this time.

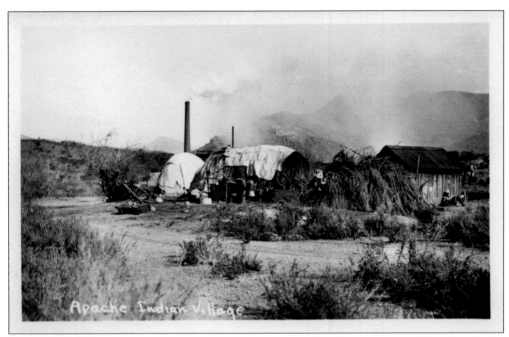

As copper mining developed after 1900 in the vicinity of Globe, just west of the San Carlos Apache Reservation, Apache men and women were able to find employment in the mining towns. A small Native American camp would often be located just outside the main camp. Smelter smokestacks can be seen behind this village, photographed in the 1920s or 1930s.

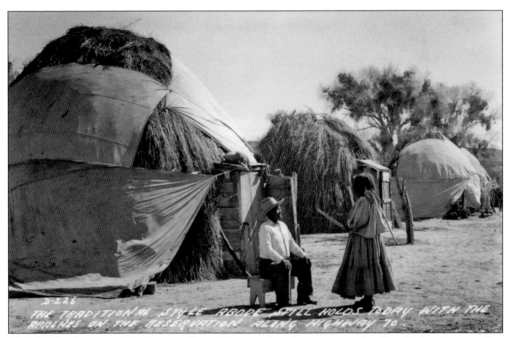

This 1930s photographic view depicts a Western Apache camp on the San Carlos Reservation along U.S. Highway 70. The traditional canvas-covered wickiup was still in use as a habitation but with the addition of a wooden front door to replace the earlier blanket or piece of hide.

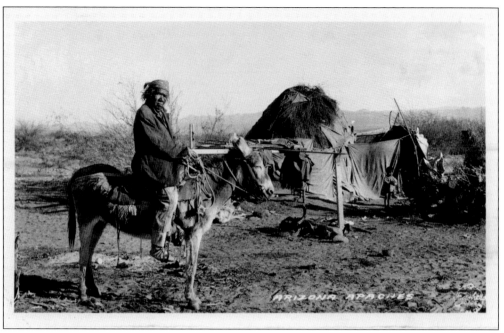

This early-1940s view of a mounted San Carlos Apache elder shows him with Anglo-style clothing except for the headband and leather moccasins. His canvas-covered wickiup home is in the background.

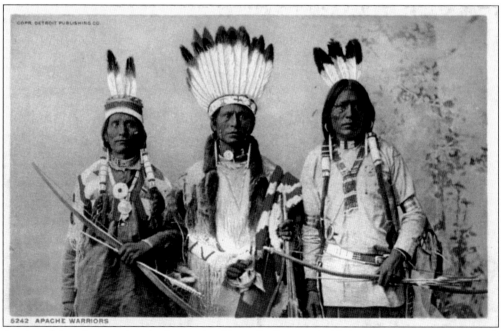

A trio of Apache warriors is shown in this early Detroit Publishing Company image, with traditional buckskin clothing, ornamentation, headdresses, and weapons.

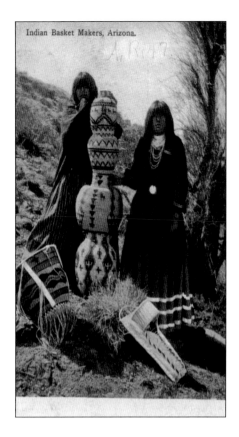

Indian Basket Makers, Arizona.

Western Apache women have long been noted for their tightly woven basketry with intricate designs. These two posed images of Apache baskets—note that two of the baskets are the same in each picture—show primarily jar or olla forms. A conical burden basket can be seen at the lower left of the upper image. Interestingly, both styles of Western Apache cradle boards are shown in these views, the difference being the vertical versus horizontal slats in the cradle hood.

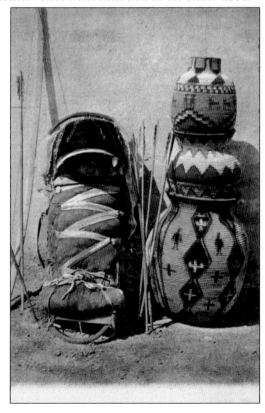

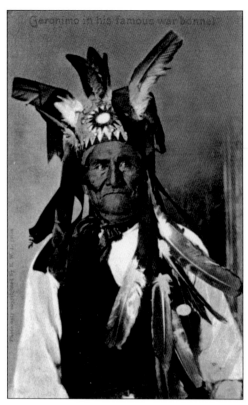

The famous Chiricahua Apache leader Geronimo, known to his followers as "Goyathlay," was born in southern Arizona in 1829. In his early days, he rode with other well-known Apache leaders of the era such as Cochise, Mangas Coloradas, and Victorio. It was not until the Chiricahuas were moved to the San Carlos Reservation in the 1870s and frustration with the reservation system began to mount that Geronimo began to emerge as the leader of the hostile Apaches. For 10 years, he led his small band of warriors against overwhelming odds, finally surrendering in 1886.

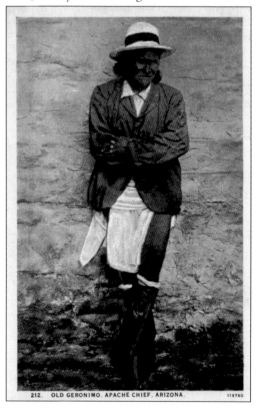

212. OLD GERONIMO, APACHE CHIEF, ARIZONA.

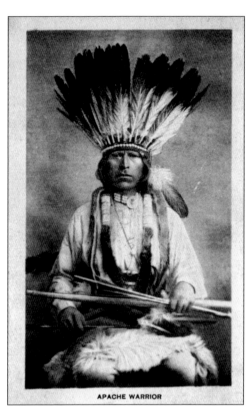

APACHE WARRIOR

This early image of an Apache warrior is not attributed to a particular group. The posed view shows traditional attire, headdress, and weaponry.

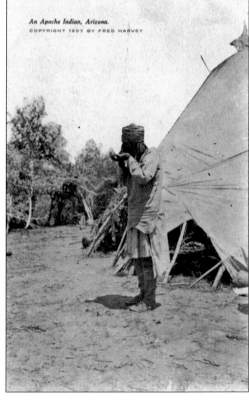

An Apache man is shown in camp in this 1907 Fred Harvey image. He is dressed in typical, late-19th-century Apache attire—headband, a cloth breechclout with overlapping shirt, and to-the-knee buckskin moccasins.

Montera Cabezon, a young Arizona Apache man, is shown dressed in his finest apparel in this Fred Harvey image from about 1915. Included are a fully beaded vest; bone, bead, and shell choker; and hair ornament.

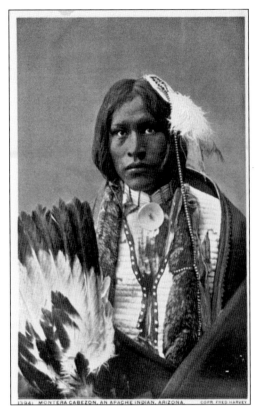

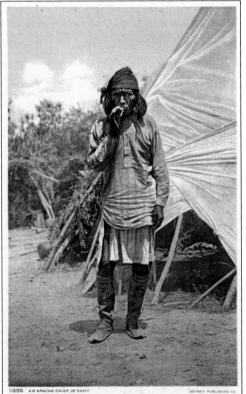

This view of an Apache chief in camp is probably from the White Mountain Apache area. Each local group of Western Apaches had its own leader who directed the group in matters of importance, such as war or raiding parties, food gathering trips, and relations with other groups.

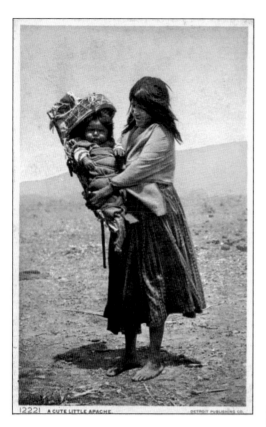

12221 A CUTE LITTLE APACHE. DETROIT PUBLISHING CO.

An Apache mother and baby pose for this image around 1915. Usually a baby had only one permanent cradle, made about three months after birth, but occasionally a second, larger one was made.

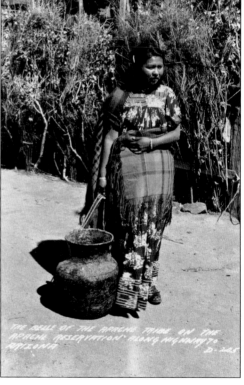

This image, from about 1940, shows a young San Carlos lady in commercial dress and shawl. At her right side is a large *tus*, a pine pitch covered basket used for water carrying or storage. Larger ones were also used to bury food caches.

This image shows a San Carlos Apache mother and daughter, both dressed in the 1930s-style blouses and skirts. The girl wears a commercial leather shoe on her left foot.

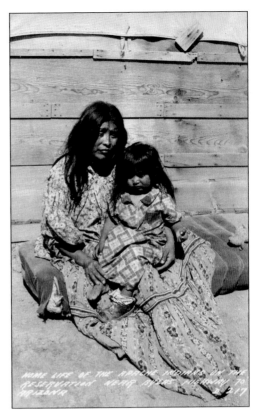

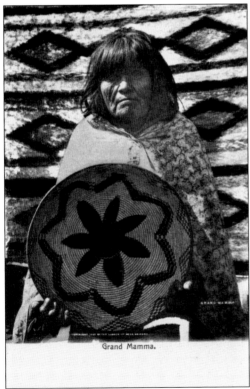

Grand Mamma.

This early image from around 1907 shows a woman, who is probably Western Apache, with a superior example of her basketry handiwork.

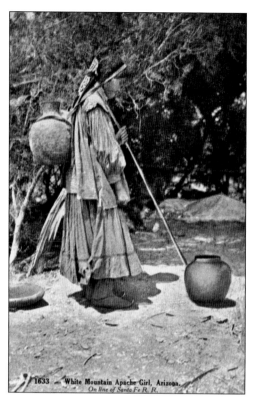

1633 — White Mountain Apache Girl, Arizona.
On line of Santa Fe R. R.

This White Mountain Apache girl is clothed in the traditional, two-piece calico dress with high-topped moccasins exhibiting the Apache-style turned-up toe tab. On her back is a *tus,* the pitched water-carrying container, secured in place by a tumpline across the forehead.

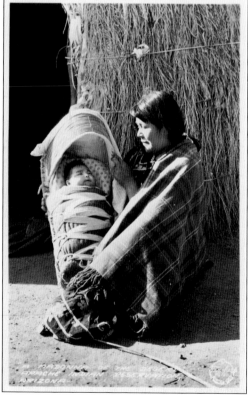

This San Carlos Apache mother is posed outside the door of her wickiup home with her baby in a permanent cradle board. Western Apache wooden cradle boards are typically painted or stained yellow with cloth of the same color.

74

Chief Talkalai was leader of the Apache Peaks Band of Apaches at the San Carlos Reservation. Born in 1817, he is pictured here at the age of 99. He served as both a scout for the U.S. Army and in the San Carlos Indian Police in the 1870s.

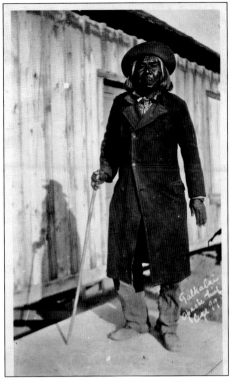

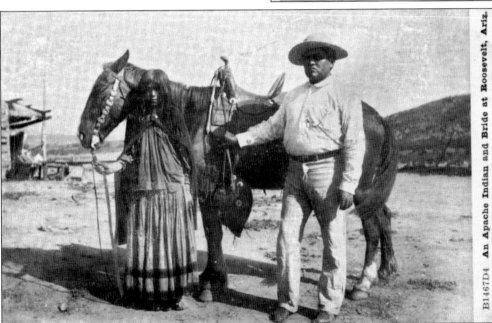

An Apache Indian and his bride at Roosevelt, Arizona, were photographed sometime in the 1920s. The woman is dressed in the traditional Apache camp dress, a two-piece skirt and blouse with shawl that became common apparel for women about 1900. She is also wearing buckskin moccasins, while the groom is entirely dressed in Anglo clothing, complete with either store-bought shoes or cowboy boots.

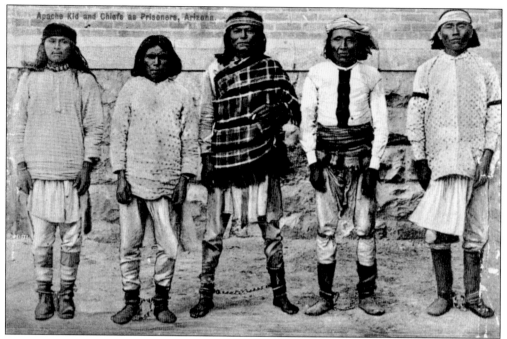

This postcard of the "Apache Kid and Chiefs as Prisoners, Arizona" was produced around 1907. The Apache Kid was an Apache scout at San Carlos from 1881 to 1887. A series of events, including mutiny, desertion, and attempted murder, lead to him becoming an outlaw fugitive for the rest of his life.

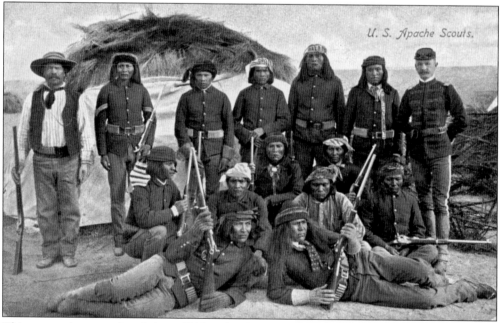

This postcard was produced about 1910 and is from a *c.* 1890 photograph showing a contingent of Apache scouts at Camp San Carlos with their interpreter, Merejildo Grijalva (left) and commanding officer Lt. Charles E. Tayman of the 24th Infantry (right). The 24th Infantry was a Buffalo Soldier regiment that had a detachment at San Carlos beginning in 1888.

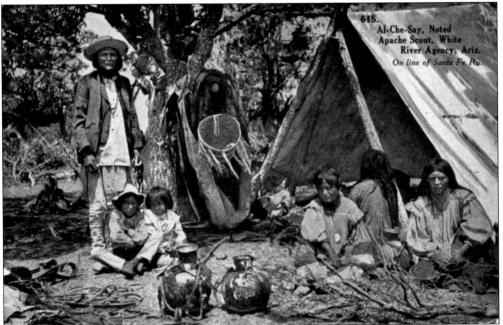

William Alchesay (1853–1928) was a White Mountain Apache who enlisted in the U.S. Army Indian Scouts in 1872. For his bravery in the early Apache Indian Wars, he was awarded the Congressional Medal of Honor in 1875. Still in service, he participated in the 1886 campaign that ultimately ended in the capture of Geronimo. He was a respected chief of the White Mountain Apache tribe, and in 1956, the high school at Whiteriver on the Fort Apache Reservation was named in his honor.

11257 AL-CHE-SAY WHITE MOUNTAIN APACHE SCOUT UNDER GENERAL CROOK.

615.
Al-Che-Say, Noted Apache Scout, White River Agency, Ariz.
On line of Santa Fe Ry.

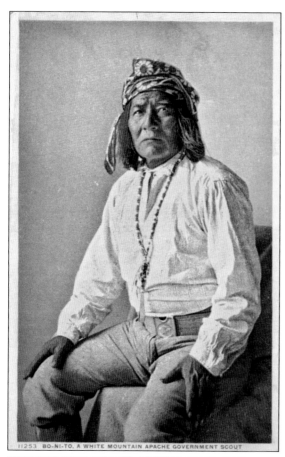

11253 BO-NI-TO, A WHITE MOUNTAIN APACHE GOVERNMENT SCOUT

A White Mountain Apache and member of Alchesay's group, Bonito was also a scout for the U.S. Army at Fort Apache in the early 1870s. Later he married a Chiricahua woman and became a leader among the Chiricahuas, engaging the army in hostile actions in the early 1880s. Following that action, he once again became an army scout and was discharged in 1891 as a first sergeant.

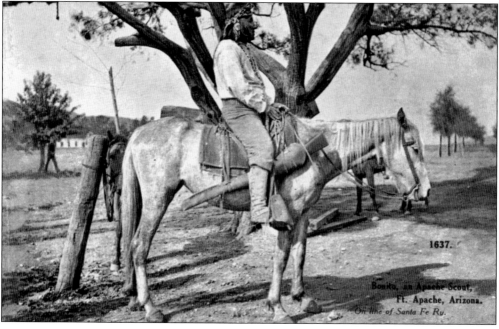

1637.

Bonito, an Apache Scout,
Ft. Apache, Arizona.
On line of Santa Fe Ry.

The institution known as the Apache Scouts came into being as a result of Gen. George Crook being named commander of the U.S. Army's Department of Arizona in 1871. Recognizing that his regular soldiers were no match for the Apaches and neighboring tribes he was sent to subdue, Crook enlisted 50 men from the bands at Fort Apache to serve as scouts for his units. The scouts would play a decisive role over the next 15 years of the Apache Wars in Arizona. Following closure of army posts and forts in the region, remaining Apache Scouts were transferred to Fort Huachuca, Arizona, where they continued to serve until the last four scouts retired in 1947.

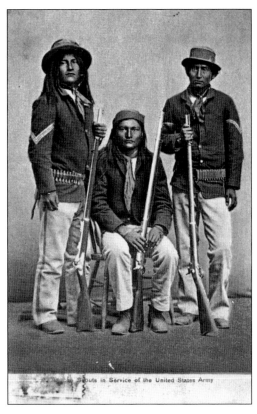

Scouts in Service of the United States Army

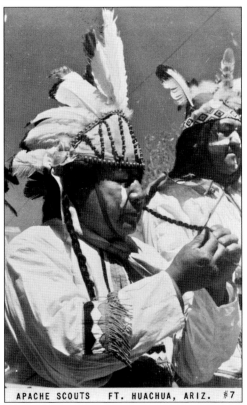

APACHE SCOUTS   FT. HUACHUA, ARIZ.   #7

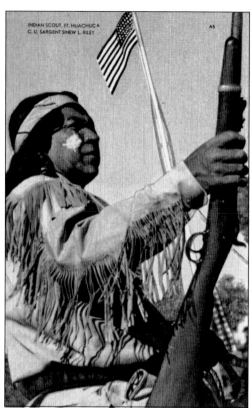

S.Sgt. Sinew L. Riley, leader of the last Apache Scouts at Fort Huachuca, and his fellow scouts spent the last years of their service performing mainly ceremonial roles, appearing in costume for parades and other events.

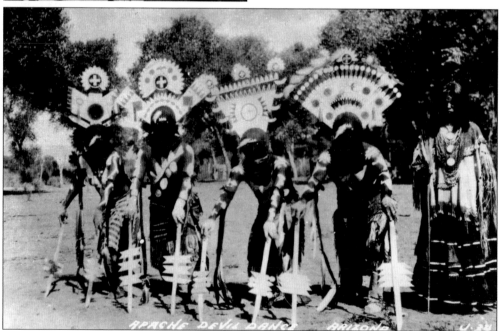

Central to Western Apache ritual and ceremonies are masked dancers impersonating the supernatural spirits of *gaan*. These dancers perform at various curing ceremonies and at a girl's puberty ceremony, as shown in this image.

*Four*

# DESERT TRIBES

Native American peoples who traditionally occupied the expansive deserts of southern Arizona include four tribal groupings: the Tohono O'odham (formerly Papago) or "desert people," the Pima (Akimel O'odham) or "River People," the Maricopa (Piipaash), and the Yaqui (Yoeme). Today the Tohono O'odham Nation incorporates four separate reservations (the first was established in 1874), and they share the Ak Chin Reservation with the Pima. The Pima and Maricopa share lands on the Gila River Reservation (established 1859) and Salt River Reservation (established 1879) near Phoenix with the Yaqui living on the Pascua Reservation (established 1964) near Tucson and four other small villages in southern Arizona.

The Tohono O'odham and Pima have historically shared a common language and lived scattered throughout the Sonoran Desert of the western two-thirds of southern Arizona and northern Sonora, Mexico. Environmental adaptation followed one of two paths, depending on geography and availability of food and water resources. In the first instance, each village had two seasonal locations. From spring to fall, the people lived near the mouth of a wash where flash floods from summer rains provided water to cultivate fields, and desert plants, particularly the fruit of the saguaro cactus, could be used. During the winter, villages were located close to springs in higher elevations where hunting became the primary source of food. The second pattern occurred along major rivers in the region where year-round habitation based on cultivation of crops and an increased water supply was possible. There was also a greater availability of wild plants and animals.

The Maricopa originated from the lower reaches of the Colorado River and migrated eastward along the Gila River drainage in precontact times, ending up adjacent to the Pima. The Maricopa also relied on the waters of the Gila River for agriculture.

The traditional territory of the Yaqui people was along the Yaqui River in southern Sonora, Mexico, where many Yaquis still live today. In the 1890s, political unrest in Mexico forced some Yaquis to abandon their villages and enter the United States as political refugees, eventually settling in small villages in southern Arizona.

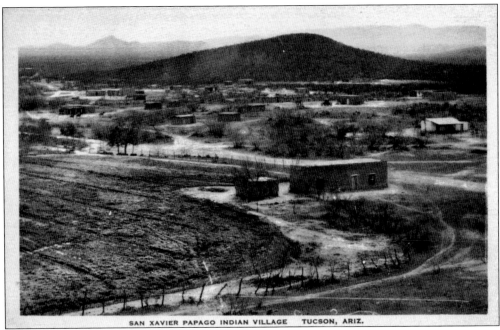

SAN XAVIER PAPAGO INDIAN VILLAGE   TUCSON, ARIZ.

In 1697, the Jesuit missionary Father Eusabio Francisco Kino established the mission San Xavier del Bac, located on the southwest edge of present-day Tucson. The Tohono O'odham village that grew around the mission would eventually become the first reservation for the O'odham in the United States in 1874.

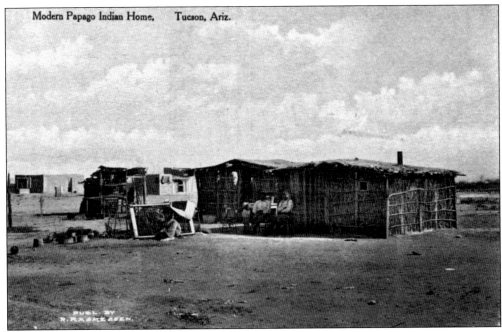

Modern Papago Indian Home,   Tucson, Ariz.

Many Tohono O'odham houses in the permanent villages imitated the rectangular adobe of their early Mexican neighbors, although the native construction technique of using mud and vertical poles was still used for structures at the beginning of the 20th century.

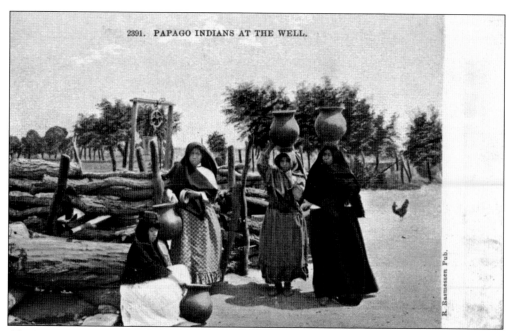

Obtaining water at the well was a daily task for Tohono O'odham women. Water was carried in large ceramic ollas on the head, resting on a bark ring. Since the vessels were porous, seepage and evaporation kept the water cool inside the home.

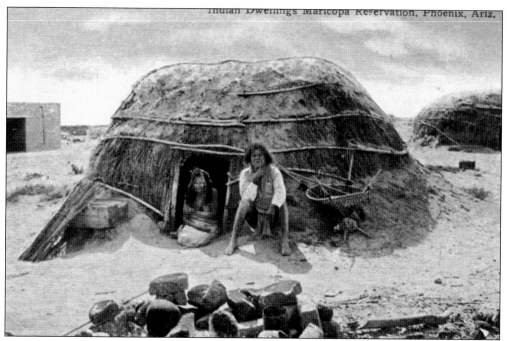

Indian Dwellings Maricopa Reservation, Phoenix, Ariz.

Shown in this *c.* 1910 view is a traditional, round, flat-topped house on the Maricopa (today Ak Chin) Reservation, about 30 miles south of Phoenix. By 1900, the United States Indian Department was encouraging the Maricopa and their neighbors, the Pima, to abandon this type of dwelling in favor of a more standard adobe house.

83

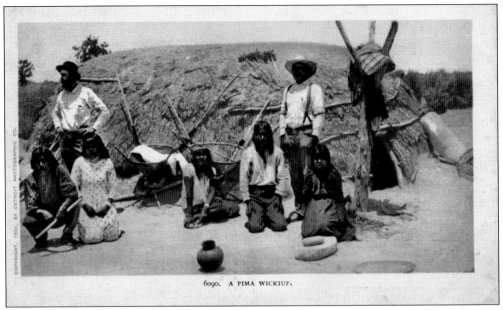

6090.  A PIMA WICKIUP.

As reflected in this 1902 Detroit Photographic Company image, the early Pima house (*ki*) was constructed in a manner similar to the Maricopa structures. These houses ranged up to 25 feet in diameter and formed a suitable shelter against desert monsoon storms.

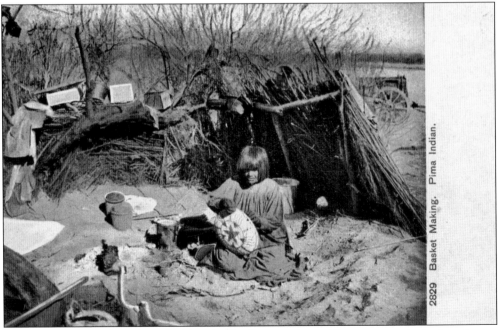

2829  Basket Making.  Pima Indian.

In this *c.* 1910 view from the Gila River Indian Reservation, a Pima woman sits in the arbor or brush shade weaving a tightly coiled basket. Anglo influences are evident by the wooden boxes on the roof, metal containers, a white ceramic coffee cup lying to the right of the woman, and the wagon in the upper right.

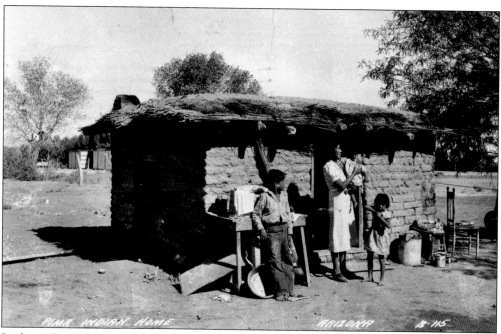

In the early 1900s, the adobe brick home with thatched roof became much more common on the Pima reservation. To encourage construction of this type of house, the federal government offered a wagon to men who would cut off their long hair and build an adobe home.

The title of this early postcard is "Photographed for the first time, near Phoenix, Ariz." The men are probably Pima, although they could be Fort McDowell Yavapai.

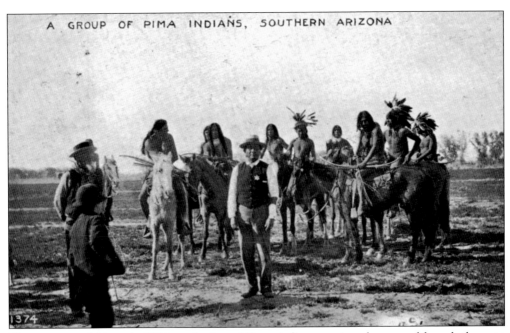

A GROUP OF PIMA INDIANS, SOUTHERN ARIZONA

1374

The purpose of this early 1900s gathering of Pima Indian men is unknown, although the man at the center appears to be a tribal policeman.

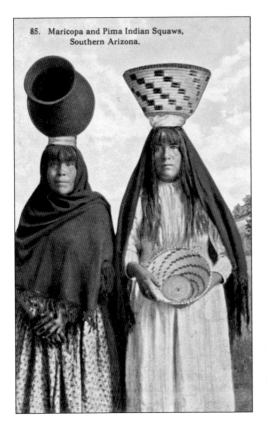

85. Maricopa and Pima Indian Squaws, Southern Arizona.

This image from around 1910 shows Pima and Maricopa women in the manner of dress for that time along with the method of supporting both ceramic vessels and baskets on the head.

This image, printed between 1904 and 1918, shows two O'odham women dressed in the style of the early 1900s with commercial cloth dresses and shawls and posed in front of the giant saguaro cactus, an economically important species for the desert people.

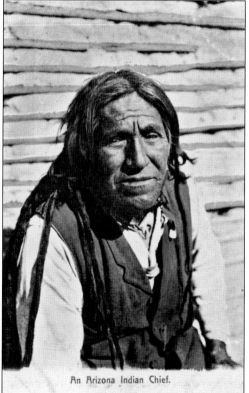

An Arizona Indian Chief.

This is an image of an "Arizona Indian Chief," probably either Pima or Maricopa. The exterior of the house in the background shows the finished appearance with wood ribs of the saguaro cactus set horizontally to hold the adobe in place during rain storms.

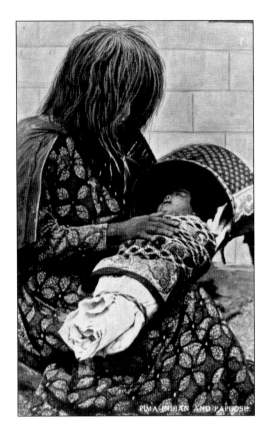

PIMA INDIAN AND PAPOOSE

The O'odham baby spent at least the first year of life in the cradle board. During this period, the mother carried it lying flat, either balanced on the head or under the arm supported on the hip. The cradle was formed of several parts, including a flat board frame, a mattress of willow bark strips, and a detachable hood made of willow bark in the checker style of weaving. A loose piece of cloth could be thrown over the hood to protect the youngster from flies.

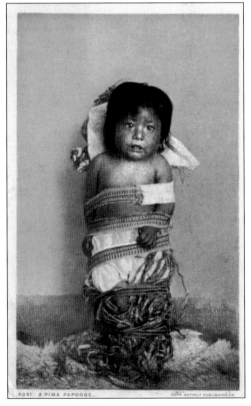

A PIMA PAPOOSE.

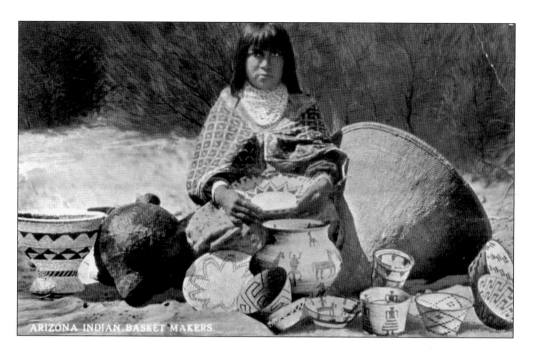

ARIZONA INDIAN BASKET MAKERS.

The Tohono O'odham and Pima, and to a lesser extent the Maricopa, have long been recognized as skillful makers of coiled basketry. Owing to the plentiful availability of suitable materials in the desert environment for manufacturing sturdy baskets, these containers served a number of purposes, including carrying loads, storage, and flat bowl-like baskets for winnowing seeds or serving food. The variety of shapes and design elements is shown in these two views of basketry from around 1910.

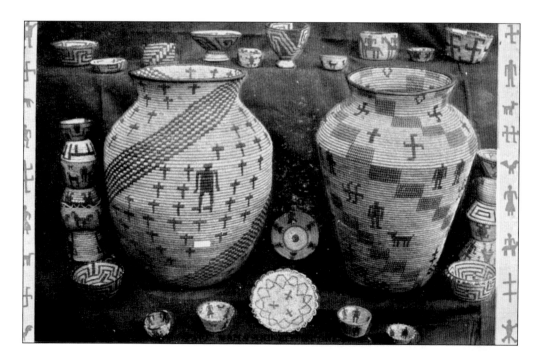

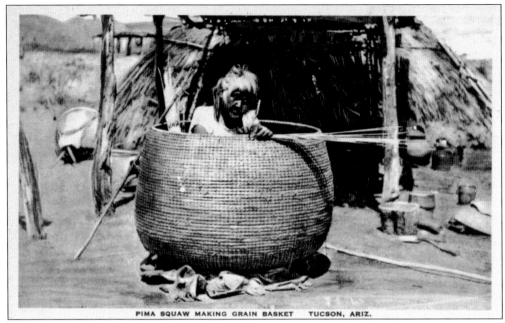

PIMA SQUAW MAKING GRAIN BASKET    TUCSON, ARIZ.

Large, coarse-coiled baskets were woven for the storing of wheat, corn, wild seeds, and shelled beans. Storage bins of this type were usually kept indoors in the house.

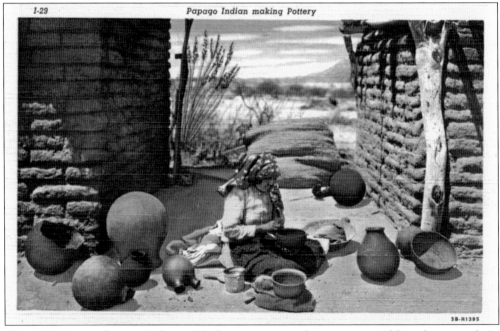

I-29                                    Papago Indian making Pottery

This 1940s image shows a Tohono O'odham woman making pottery. Although not made in plentiful numbers compared to basketry, ceramic vessels were important for cooking, storage, and as water containers in the household. A large storage basket can be seen at center rear.

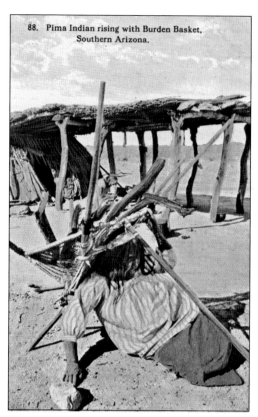

88. Pima Indian rising with Burden Basket, Southern Arizona.

Commonly used by the O'odham peoples, the woman's conical carrying basket (*kiaha*) was made to rest on a tripod of sticks while on the ground. It could be loaded with wood and other bulky items, then employing a tumpline across the forehead, the woman would rise with the load. A helping stick was used to steady the load and help the woman rise. Young girls of 8 to 10 would begin to use small *kiahas* made especially for them to gain strength and experience for carrying heavy burdens expected in adulthood.

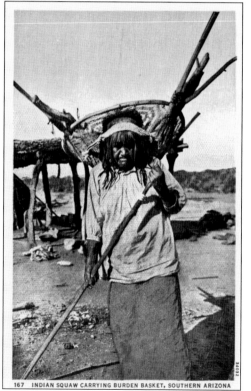

167   INDIAN SQUAW CARRYING BURDEN BASKET, SOUTHERN ARIZONA

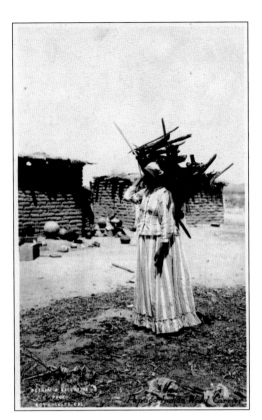

Using the *kiaha* burden basket, O'odham women could carry loads weighing nearly 100 pounds over long distances. Often, the load weight exceeded that of the woman.

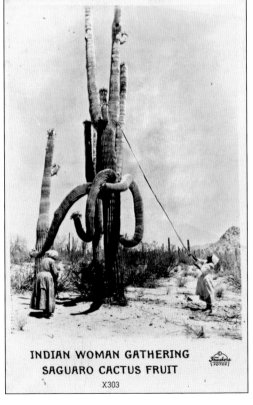

**INDIAN WOMAN GATHERING
SAGUARO CACTUS FRUIT**

X303

Harvest of the fruit of the giant saguaro cactus usually began about the month of June and was facilitated by the use of a saguaro hook, an elongated pole made of the woody ribs of the cactus itself with a small, straight piece of wood attached at the end to dislodge the fruit pods.

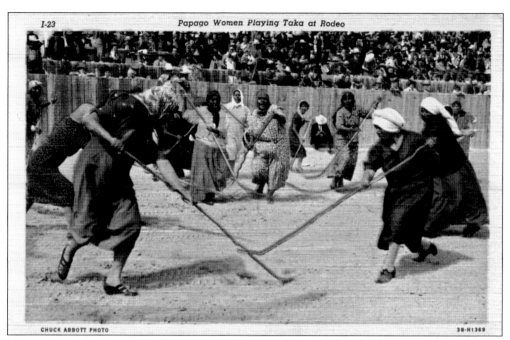

The traditional Tohono O'odham woman's game of *toka* was played with two sticks usually tied together by a short cord and a double ball. The goal was to throw the double ball past the opponent's goal.

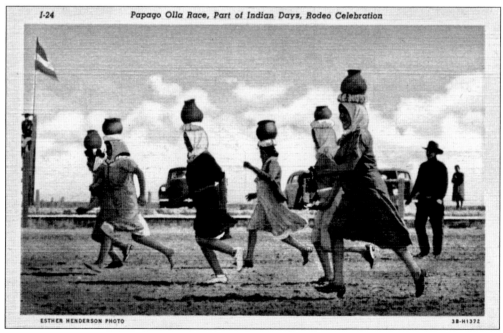

Another Tohono O'odham woman's game was the olla race, a popular favorite at rodeo celebrations in southern Arizona.

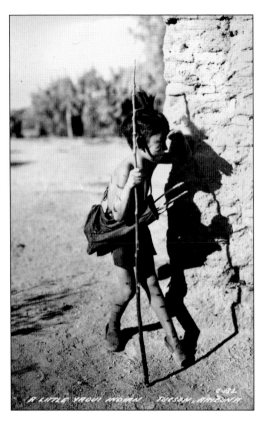

The Yaqui of southern Arizona emigrated from northern Mexico in the late 1800s to avoid persecution by Mexican national troops. The largest U.S. village is Pascua, located at the southwest edge of Tucson. A young Pascua Yaqui warrior relives the period of turmoil of his ancestors in this image from the 1940s.

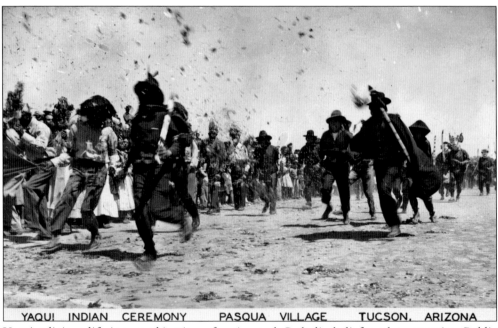

Yaqui religious life is a combination of native and Catholic beliefs and ceremonies. Public performances occur on saints' days, Easter, and Christmas.

# *Five*

# COLORADO RIVER TRIBES

Native American tribes located along the Colorado River in Arizona can be separated into lower and upper groupings. Modern-day tribes and reservations along the lower part of the river include the Cocopah (reservation established in 1917), Quechan or Yuma (Fort Yuma Reservation, established 1884), Fort Mohave Reservation (established 1870), and the Colorado River Indian Tribes Reservation (established 1865). Farther up the river, in the vicinity of Grand Canyon National Park, are the Havasupai Reservation (established 1880) and the Hualapai Reservation (established 1883).

The Lower Colorado tribes, Cocopah, Mohave, and Quechan, along with the Chemehuevi to the north, shared cultural traits in precontact times, associated with proximity to a major river valley. The people were primarily agriculturalists—crops of corn, beans, and pumpkins were grown on the fertile floodplain. Wild desert plants, small game, and fish supplemented the diet. The groups maintained a strong sense of tribal identity, although a formal, intergroup political organization did not exist. They lived in small, widely scattered settlements along the river bottoms. Leaders led by respect accorded to them by other tribal members and by moral strength, not by the authority of their post. All except the Chemehuevi lived in a variation of houses made of wood poles and mud scattered along the bottomlands of the Colorado River valley.

The Hualapai and Havasupai, along with the nearby and linguistically related Yavapai, comprise the upland groups of the Yuman language. The Hualapai were historically a small tribe whose population did not exceed 1,000. They lived in tiny settlements, consisting of two or three families. In the winter, the Hualapai spent time on the plateau above the river, hunting and collecting plentiful food and animal resources. During the summer, they moved to the canyon and practiced limited agriculture. The Havasupai live upriver from the Hualapai in the depths of the Grand Canyon itself. Today they are considered the most isolated Native American tribe in the United States. Their economic livelihood was similar to that of the Hualapai. Both tribes were known for their basketry, particularly the large, conical burden basket used for gathering foodstuffs.

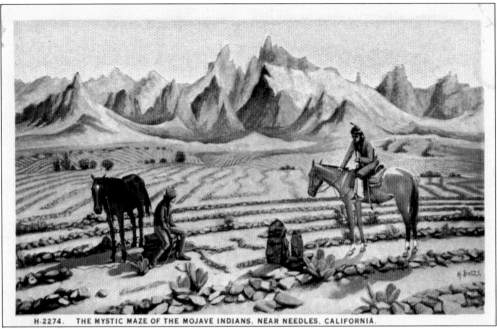

The Toprock Maze once covered more than 50 acres of desert on a bluff above the Colorado River near Needles, California. The ancient pattern of stone lines on the desert floor marks the pathway to the afterlife for the Mohave Indians.

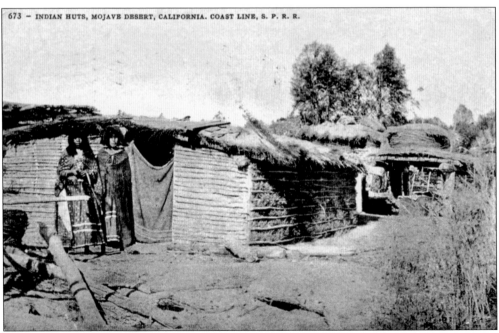

This image, mailed in 1908, shows the traditional Yuman houses along the line of the Southern Pacific Railroad, which crossed from Arizona to California at the southern edge of the Fort Yuma Reservation.

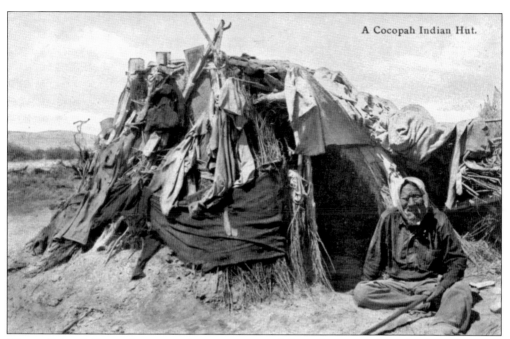

A Cocopah Indian Hut.

The traditional Cocopah summer house was an oval domed or conical postless hut with walls of vertical reeds or brush. In this view from around 1910, the exterior is covered with canvas and other cloth pieces. The roof was used for food storage containers and utensils.

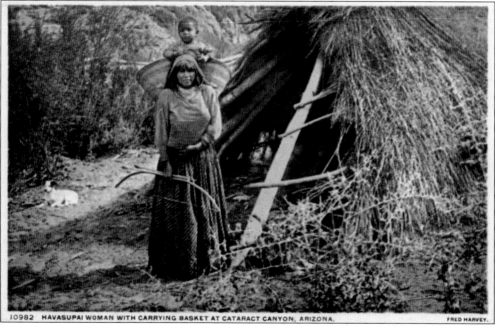

10982   HAVASUPAI WOMAN WITH CARRYING BASKET AT CATARACT CANYON, ARIZONA.                    FRED HARVEY.

Since historic times, the Havasupai have lived in the cooler bottom of the Grand Canyon in the summer months where cultivation of corn, beans, and squash took place. The traditional summer home was a domed or conical structure of thatch.

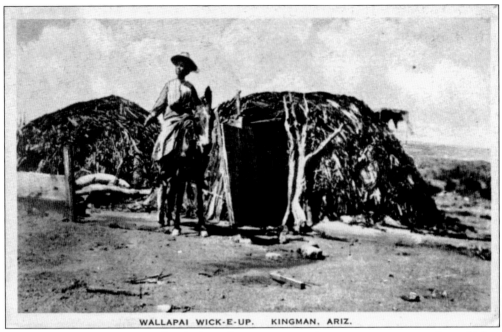

WALLAPAI WICK-E-UP.    KINGMAN, ARIZ.

The early reservation–era Hualapai winter home was a semipermanent structure, about 14 feet long with an 8-foot domed roof and thatched with plant material or juniper bark. This postcard image was mailed in 1925.

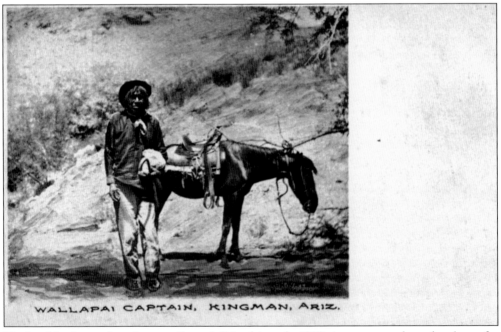

WALLAPAI CAPTAIN, KINGMAN, ARIZ.

Hualapai leaders, referred to as a "captain" in this early 1900s image, served as a headman for several families who resided together in camps. His duties included offering advice, making decisions necessary to coordinate subsistence activities, and admonishing unruly children.

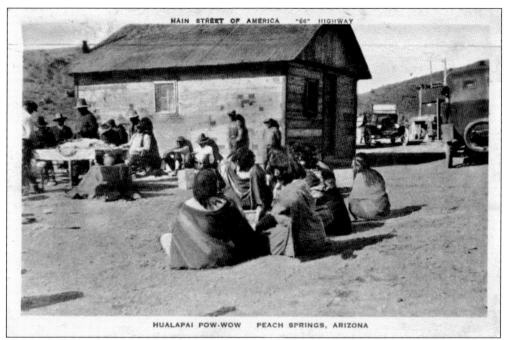

HUALAPAI POW-WOW    PEACH SPRINGS, ARIZONA

This 1920s image shows a gathering of Hualapai leaders at Peach Springs, Arizona. Groupings of neighboring camps united politically into bands, which in turn allied with other bands from adjacent territorial ranges, forming subtribes. Three Hualapai subtribes were recognized.

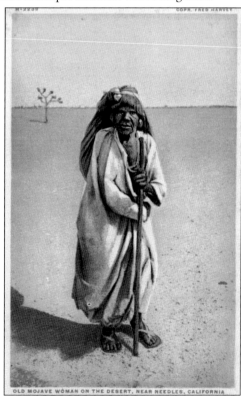

OLD MOJAVE WOMAN ON THE DESERT, NEAR NEEDLES, CALIFORNIA

A Mojave woman is shown in this Fred Harvey image from around 1910. The women carried burdens in a netted or cloth sack attached to a tumpline passed over the forehead. Although centered on the Colorado River, Mohave territory extended into the more barren reaches of the surrounding desert.

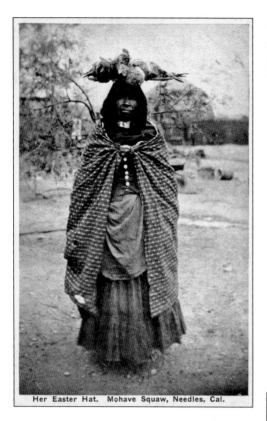

Her Easter Hat.   Mohave Squaw, Needles, Cal.

This Mohave woman is shown in typical, early reservation-era dress of commercial material with shawl. Balanced on her head is a tray with two bound chickens.

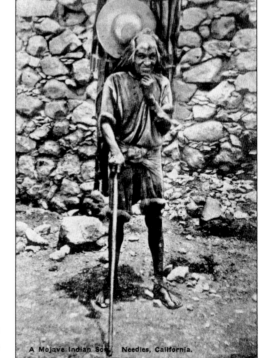

A Mojave Indian So   Needles, California.

In this 1920s image, a Mohave man carries a burden, which appears to be a bundle of driftwood from the Colorado River, a source of rich silt for bottomlands agricultural fields, food, and wood for structures and fires.

An elaborately netted beadwork cape or collar and multi-strand bead necklace adorn this young Yuma woman of the 1940s. The netted and beaded collar became popular among all Lower Colorado River tribes in the late 19th century. She also appears to wear a traditional rabbit skin blanket or robe made of twined strips of fur.

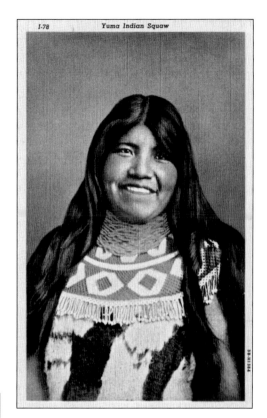

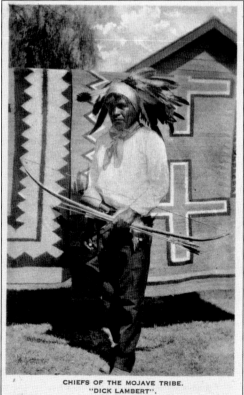

CHIEFS OF THE MOJAVE TRIBE.
"DICK LAMBERT".

A Mohave chief by the name of Dick Lambert is shown in this 1920s image. Beginning in the late 1800s, the Mohave had a head chief for the tribe, although it was more of a moral rather than commanding influence over the people. Two Navajo rugs form a backdrop.

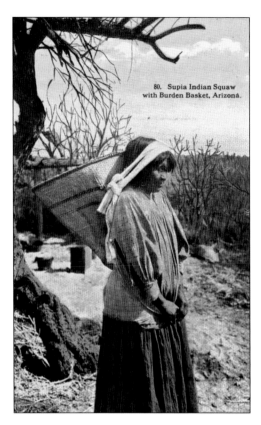

80. Supia Indian Squaw with Burden Basket, Arizona.

A Havasupai woman with a large, conical burden basket is shown in this 1920s view. The twined burden basket (*cathok*) was once indispensable in Havasupai daily life for the collection, transportation, and storage of food materials.

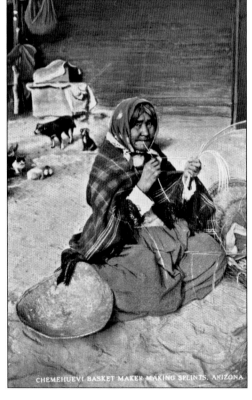

CHEMEHUEVI BASKET MAKER MAKING SPLINTS, ARIZONA

The Chemehuevi were once a small, nomadic tribe existing in the eastern portion of the Mohave Desert in California. In the late 1800s, they moved to the Colorado River area and later joined the Mohaves on the Colorado River Indian Reservation. Traditionally they were known for their finely coiled basketry.

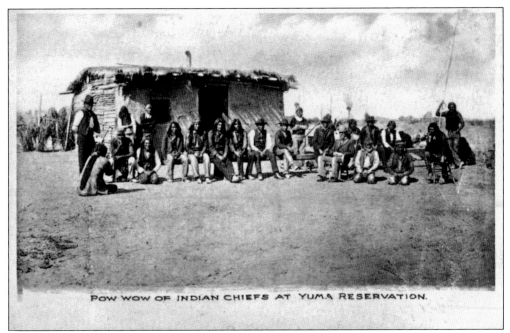

POW WOW OF INDIAN CHIEFS AT YUMA RESERVATION.

A meeting of Lower Colorado River tribal leaders at the Yuma (Quechan) Reservation is reflected in this postcard view, produced between 1901 and 1907. In late-19th-century Quechan society, each village or rancheria had one or more headmen who handled leadership responsibilities for the rancheria and met in council to resolve matters of tribal concern.

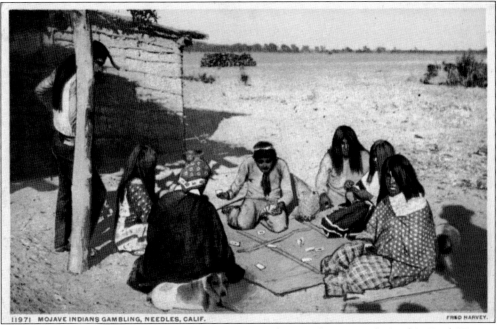

11971 MOJAVE INDIANS GAMBLING, NEEDLES, CALIF.                                   FRED HARVEY.

A group of Mohave Indians, mostly women, are shown playing cards in this Fred Harvey postcard image from about 1910.

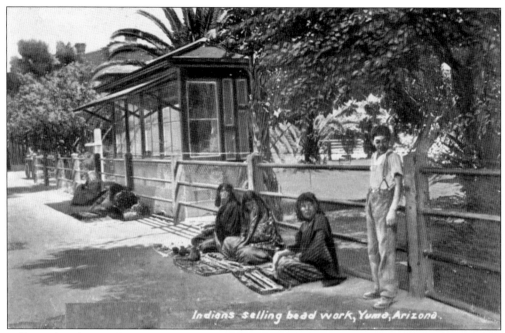

Indians selling bead work, Yuma, Arizona.

Selling of crafts at railroad stops became a popular economic pursuit in the 1890s, both for the Mohave along the Santa Fe route at Needles and the Yuma, located on the Southern Pacific line near Fort Yuma.

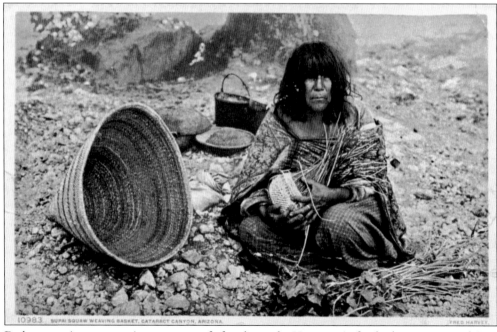

10983. SUPAI SQUAW WEAVING BASKET, CATARACT CANYON, ARIZONA. FRED HARVEY.

Basket weaving was an important craft for the early Havasupai, for baskets were used in a great number of contexts. Burden baskets, pitch–covered water bottles, seed parching trays, and stone–boiling containers were used extensively.

These two early-1900s images show a Chemehuevi girl and Mohave mother and son all clad in the style of the 1890s when commercially available cloth was used to make brightly colored dresses and shawls.

A CHEMEHUEVI INDIAN GIRL.

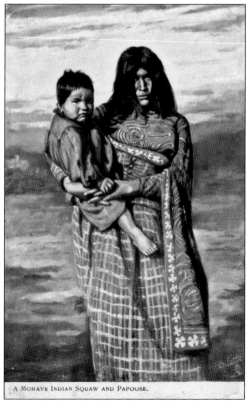

A MOHAVE INDIAN SQUAW AND PAPOOSE.

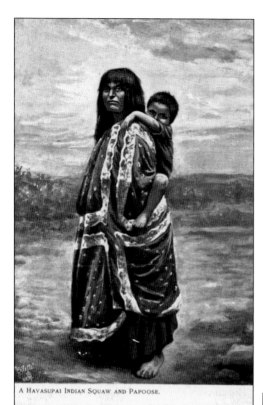

A HAVASUPAI INDIAN SQUAW AND PAPOOSE.

Two Havasupai women are shown in these images, each wearing brightly colored commercial cloth dresses and shawls.

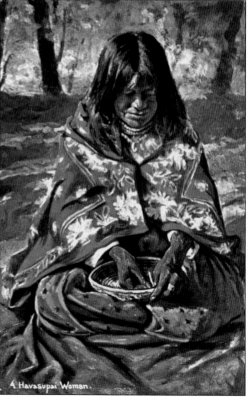

A Havasupai Woman.

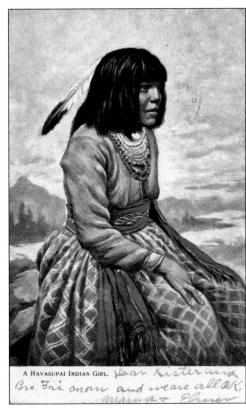

A HAVASUPAI INDIAN GIRL. *Dear Sister and Bro. Fri. mom and we are all OK mama & Elmer*

A Havasupai girl and Hualapai baby on a cradle board are shown in these images from 1908 and 1910. At about two weeks of age, the Hualapai baby was tightly bound on the cradle board where it would spend much of its first year of life.

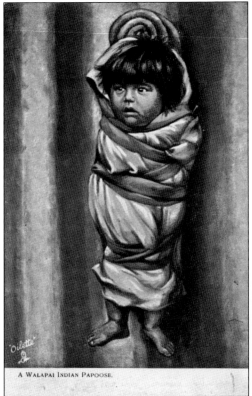

A WALAPAI INDIAN PAPOOSE.

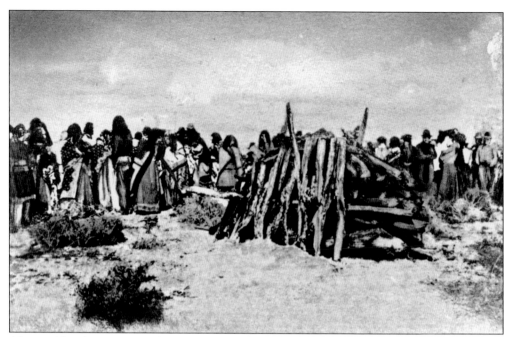

Along with other Lower Colorado River tribes, the Mohave practiced cremation of the dead. Wailing, funeral speeches, and songs preceded and accompanied cremation, at which were also burned the combustible possessions of the deceased and mortuary gifts from others.

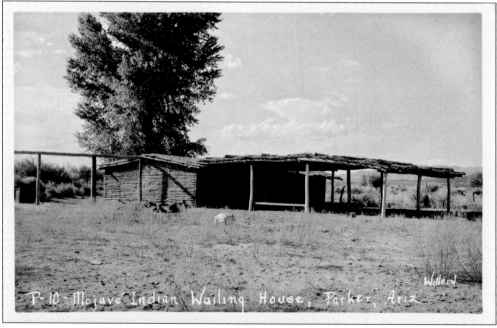

Wailing or Cry Houses were traditionally used by the Lower Colorado River tribes in which a year or later after a funeral, a ceremony was held in memory of one or more deceased tribal members. In earlier times, the house of the deceased was also burned at the funeral cremation ceremony.

# Six

# TRADERS, TOURISTS, MISSIONS, AND SCHOOLS

Beginning with the Spanish intrusions into the American Southwest in the 1540s, aboriginal ways began to be influenced by institutions associated with outsiders. First the Spanish Franciscans attempted to establish Catholic missions at various pueblos along the Rio Grande River. This included the Hopi pueblo villages in what would become Arizona territory prior to statehood. In the early 1700s, the Jesuit Order founded missions for the Pimas and Papagos of southern Arizona. After a transfer of control in the region from Mexico to the United States in the late 1800s, the missions had been established with nearly every Arizona tribe by various Protestant denominations.

Once reservations were established, other acculturative forces arose from invasive and external institutions such as trading posts, schools, and, finally, tourism. Trading posts, most visible on the Navajo and Hopi Reservations, started to take advantage of the increasing need for non-Native American goods and services. As general stores sprang up on the sprawling Navajo Reservation, a unique entrepreneurial institution began to emerge that was headed by the middleman or Native American trader. This position served two worlds of exchange—flour, coffee, canned goods, tools, and clothing in return for woven rugs, wool, sheep hides, and local products such as pinon nuts. Schools, initially confined to reservations in the form of day and boarding schools, became important avenues for forced acculturation to non–Native American ways. The Phoenix Indian School, founded in 1891, provided coeducational government-sponsored educations for primary and secondary students. By 1900, the Phoenix Indian School had nearly 700 enrolled students from some 23 Native American tribes throughout Arizona and four neighboring states.

With the improvement of transportation routes to the Southwest, particularly railroads, tourism began in earnest, and Native Americans became an immediate attraction. Tours to several reservations quickly became popular with both national and foreign visitors, as did the desire to acquire Native American–made crafts for both museums and the home. In certain instances where tribe members were not actually present, such as Grand Canyon National Park, homes were reconstructed and Native Americans were brought in to give the tourist the utmost experience.

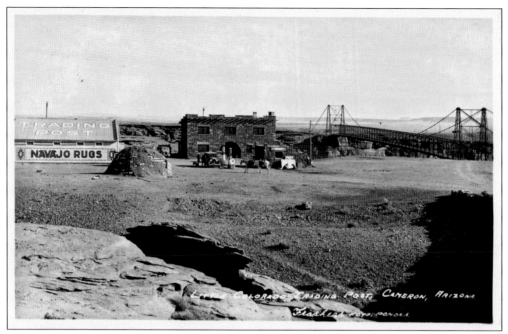

The trading post at Cameron on the Navajo Reservation along the Little Colorado River was named for R. H. Cameron, a sheriff of Coconino County in the 1890s, and built by Hubert Richardson in 1916. Since the 1950s, the Cameron post has served as a tourist stop, with a gas station, store, and hotel and restaurant for travelers on their route to the south rim of the Grand Canyon.

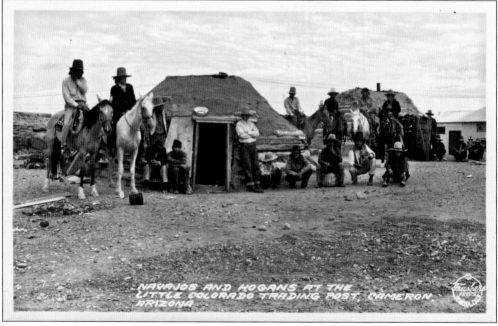

A group of Navajo men is shown in this 1930s image posed in front of the guest hogans at the Cameron Trading Post.

Visits to the trading post offered rare opportunities for leisure time and visiting. Two Navajo men are shown in this early 1940s view at the Cameron Trading Post.

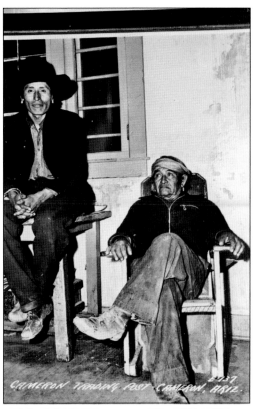

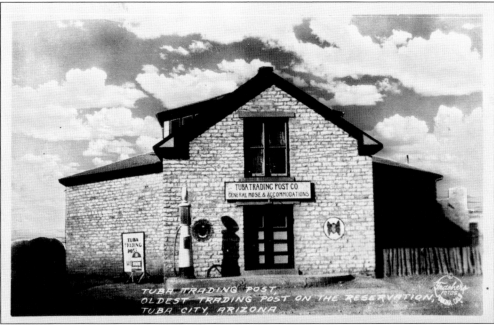

The trading post at Tuba City was one of the earliest on the Navajo Reservation and served both Navajos and Hopis from the nearby village of Moenkopi. For many years, it was one of several posts owned by the famous Babbitt Brothers of Flagstaff, Arizona.

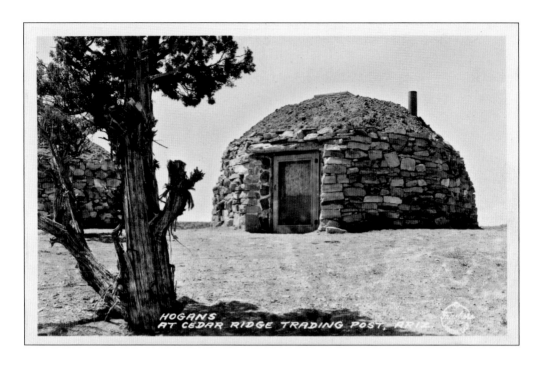

A common feature at many trading posts was the guest hogan, an example of early western hospitality. Built by Navajos at the trader's expense, the hogan was reserved for free use for any Native Americans traveling a long distance by horseback or wagon to trade. These two views show the exterior and interior of a guest hogan at Cedar Ridge Trading Post, another of the Babbitt Brothers Trading Company's business interests.

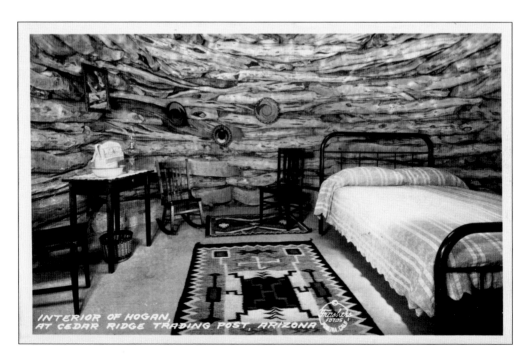

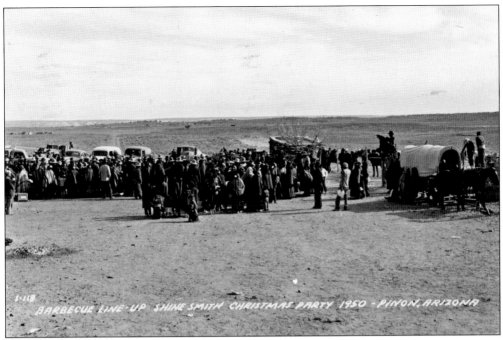

The trading post vicinity was sometimes the location of community gatherings such as this 1950 Shine Smith Christmas party at Pinon on the Navajo Reservation, located north of the Hopi mesas. Shine Smith was a Presbyterian missionary circuit rider.

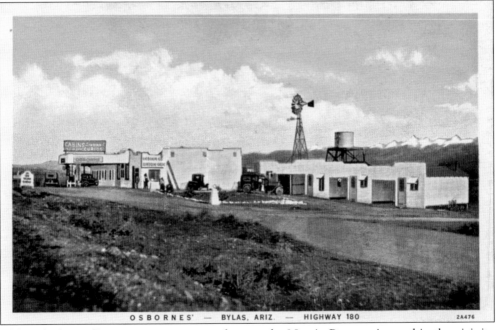

Although the trading post was most prevalent on the Navajo Reservation and in the vicinity of the Hopi villages, other Arizona reservations also had such institutions. Shown here is the trading post at Bylas on the San Carlos Apache Reservation.

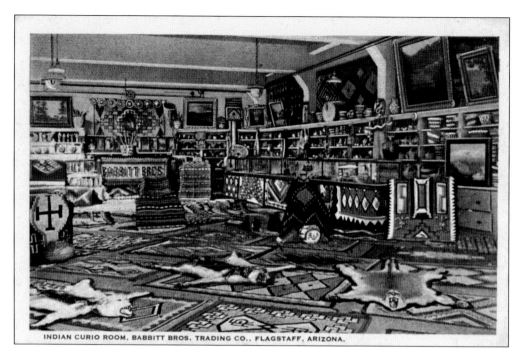

INDIAN CURIO ROOM, BABBITT BROS. TRADING CO., FLAGSTAFF, ARIZONA.

One of the functions of the reservation trading post was to acquire Native American crafts, rugs, basketry, silver jewelry, and pottery, and to market it to non–Native Americans. Two interior views of off-reservation trading posts are shown with a preponderance of Navajo rugs offered for sale to travelers, visitors, and collectors. The posts shown are the Babbitt Brothers Trading Company in downtown Flagstaff and the R. M. Bruchman Trading Post in Winslow, both located along old Route 66 in northern Arizona.

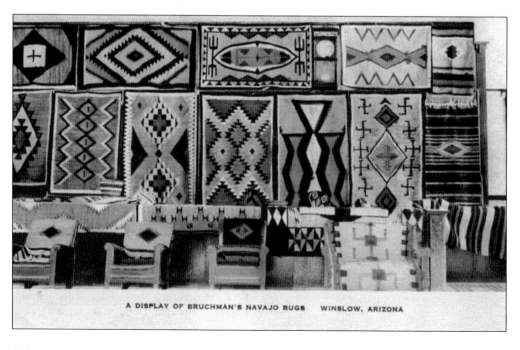

A DISPLAY OF BRUCHMAN'S NAVAJO RUGS    WINSLOW, ARIZONA

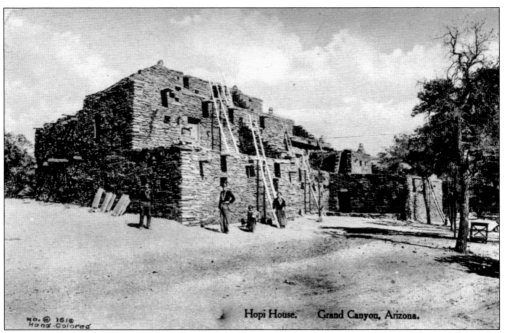

Hopi House was opened at the Grand Canyon in 1905 by the Fred Harvey Company. It was designed by renowned architect Mary Elizabeth Jane Colter. Following Hopi architectural traditions, the building was constructed primarily by Hopi workmen using native stone and wood.

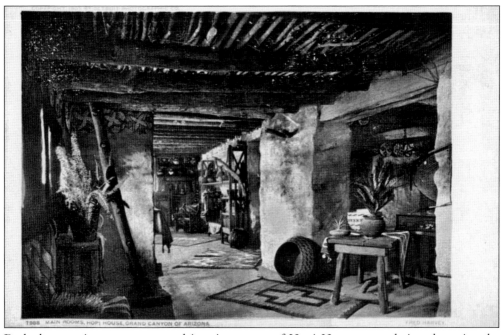

Both the exterior appearance and interior rooms of Hopi House were designed to give the tourist visitor a sense of experiencing how the Hopi Indians lived and worked, even though the building was far removed from the Hopi villages to the east.

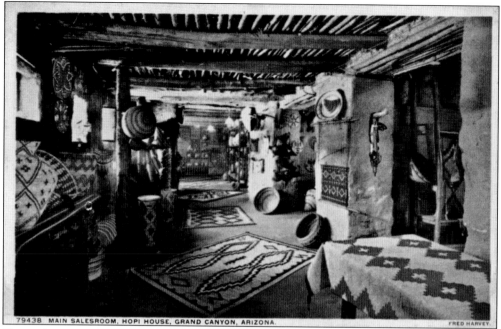

79438  MAIN SALESROOM, HOPI HOUSE, GRAND CANYON, ARIZONA.                    FRED HARVEY.

Shown here is an early view from around 1910 of the main salesroom at Hopi House. The structure was designed to give the park visitor a symbolized partnership between the romanticism of native architecture and commercialism, a hallmark of the Fred Harvey approach throughout the Southwest.

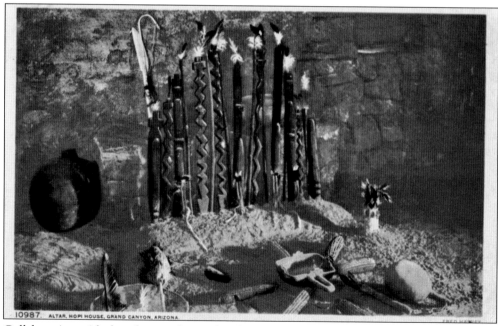

10987.  ALTAR, HOPI HOUSE, GRAND CANYON, ARIZONA.                    FRED HARVEY.

Collaborating with the ethnographer and early Mennonite missionary H. R. Voth at the Hopi villages, Mary Colter even recreated a Hopi alter scene within the confines of Hopi House.

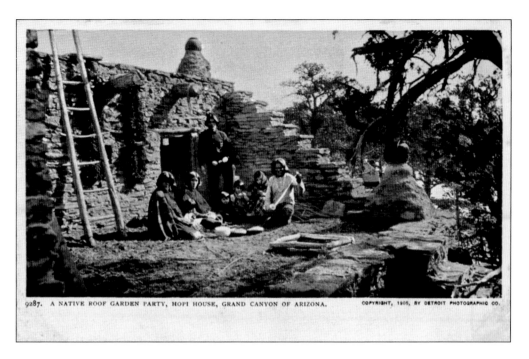

9287. A NATIVE ROOF GARDEN PARTY, HOPI HOUSE, GRAND CANYON OF ARIZONA.    COPYRIGHT, 1905, BY DETROIT PHOTOGRAPHIC CO.

To enhance the reality of Hopi House, Hopi Indians were "imported" to live and work in the recreated pueblo. In 1905, and again in 1907, the famous Hopi potter Nampeyo and her family, shown in these two views, were invited by the Fred Harvey Company to live at Hopi House. They were given room and board and could sell their crafts while demonstrating to the public.

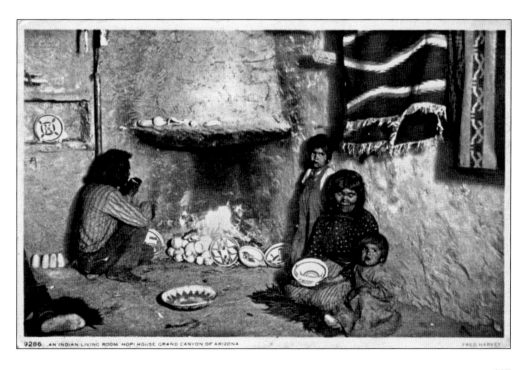

9286.  AN INDIAN LIVING ROOM  HOPI HOUSE  GRAND CANYON OF ARIZONA    FRED HARVEY

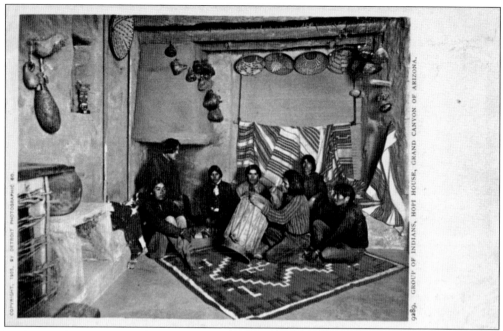

In the evenings, Nampeyo's sons and husband performed Hopi dances as part of the song and ritual dance shows that became popular with tourists.

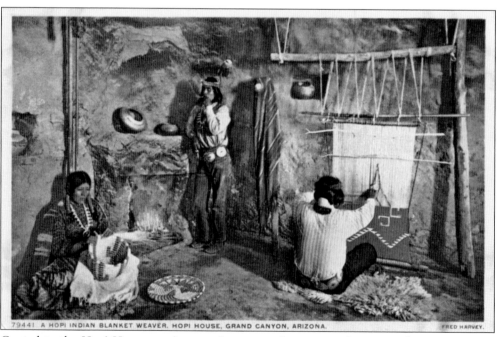

Central to the Hopi House tourist experience was the opportunity to watch native artisans create their handiworks. In this early image, a Hopi man is shown weaving a blanket.

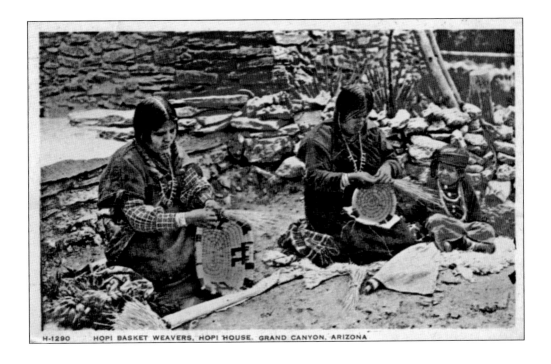

H-1290 HOPI BASKET WEAVERS, HOPI HOUSE. GRAND CANYON. ARIZONA

The foundation of Hopi craft demonstration and sales at Hopi House were the finely woven baskets and pottery. Materials for manufacture of both forms of containers had to be imported from a distance.

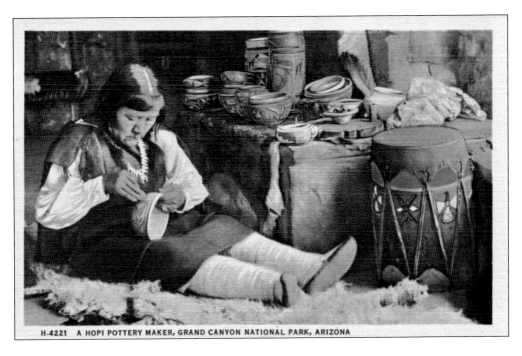

H-4221 A HOPI POTTERY MAKER, GRAND CANYON NATIONAL PARK, ARIZONA

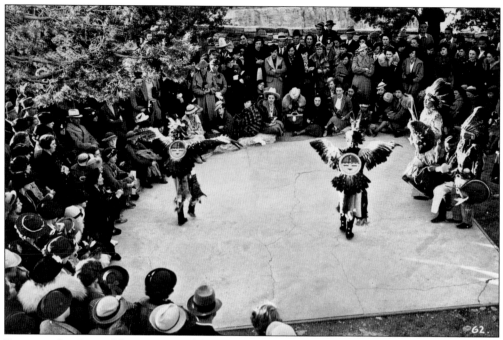

Begun at the time of the opening of the Hopi House in 1905, Hopi Indian dances just outside the building continued to be very popular with park visitors for many decades, as shown in this image from 1948.

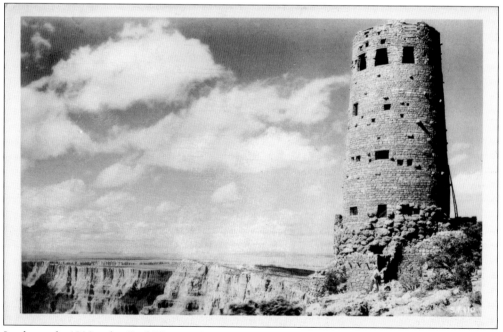

In the early 1930s, the Fred Harvey Company commissioned Mary Colter to design another building to enhance the visitor experience at Grand Canyon National Park. This one, called the Watchtower at Desert View, was constructed to imitate a prehistoric tower structure like ones found in Mesa Verde National Park in southwest Colorado.

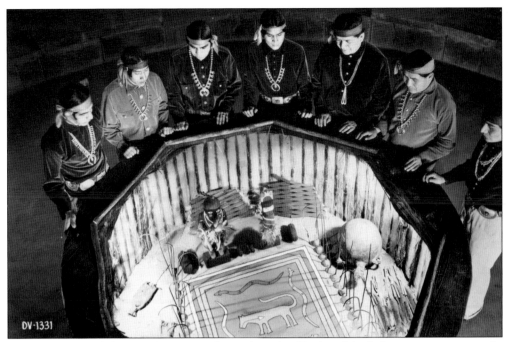

The first floor of the Watchtower is devoted to the Hopi and includes numerous artworks created by the well-known Hopi painter Fred Kabotie. In the center of the room is a replica altar derived from one in the snake kiva at Oraibi Village, and used for the famous snake dance.

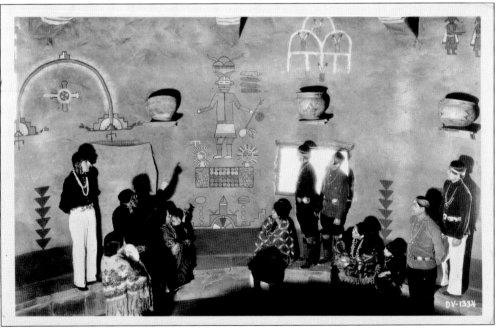

On the wall of the Watchtower, Kabotie painted traditional Hopi art symbols and scenes around the room, including a painting of Muyingua, the Hopi god of germination. Here Kabotie is seen discussing his work with fellow Hopis.

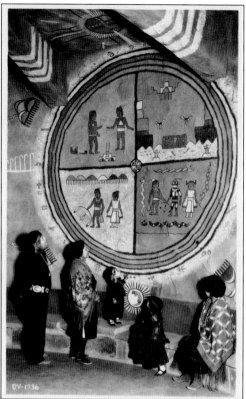

The centerpiece of Kabotie's paintings at the Watchtower is the circular mural that portrays the Hopi snake legend—the story of the first man to navigate the Colorado River through the canyon. Divided into quadrants, the painting tells the story of a young Hopi man sent out in search of the snake clan.

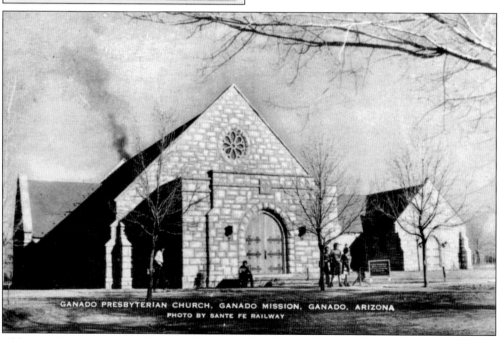

GANADO PRESBYTERIAN CHURCH, GANADO MISSION, GANADO, ARIZONA
PHOTO BY SANTE FE RAILWAY

Although Presbyterian missionaries first arrived in the southwest in the early 1870s (including missions on the Navajo Reservation), the Ganado Mission, Arizona, was not established until 1901. In its early years, the mission at Ganado included both a hospital and boarding school.

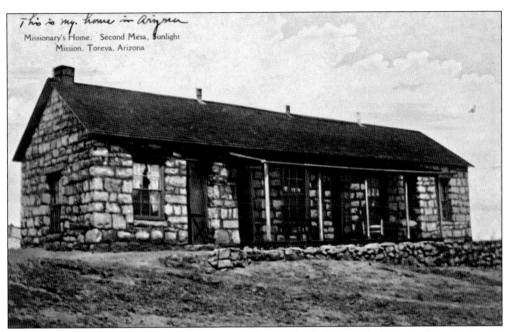

*This is my home in Arizona*

Missionary's Home. Second Mesa, Sunlight Mission. Toreva, Arizona

Under the leadership of Abigail E. Johnson (1872–1958), the Woman's American Baptist Home Mission Society established the Sunlight Missions at the Hopi villages. The first mission (1901) was at the foot of First Mesa and the second one at the foot of Second Mesa at Toreva (1907).

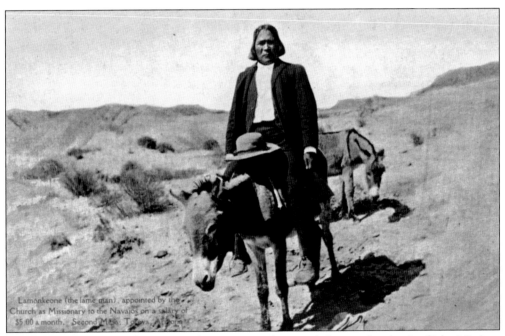

Lamonkeone (the lame man), appointed by the Church as Missionary to the Navajos on a salary of $5.00 a month. Second Mesa, Toreva, Arizona

Lomanikeoma, a Hopi from Second Mesa, served as a missionary for the Sunlight Mission. Badly crippled and known as the "Lame Man," he spoke the Navajo language and received a salary of $5 a month to carry the church's message to neighboring Navajo people.

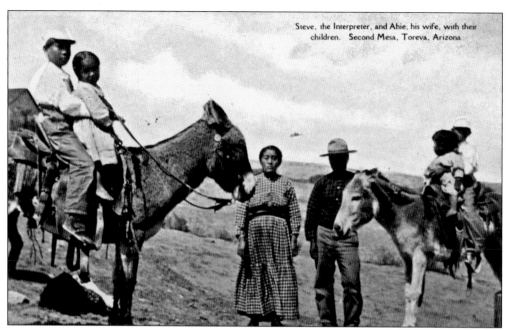

Steve, the Interpreter, and Ahie, his wife, with their children. Second Mesa, Toreva, Arizona

Steve Quonestewa from Second Mesa served as an interpreter for the Sunlight Mission. He died in 1959 at the age of 96 after being honored two years earlier for 50 years of service to the Woman's American Baptist Home Mission Society. He is shown with his wife, Ahie (Hahaye), and children.

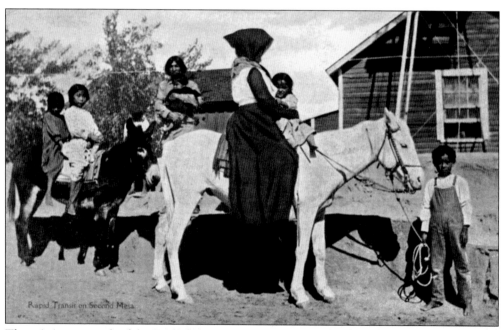

Rapid Transit on Second Mesa

The missionary work of the Sunlight Missions required considerable travel to the nearby Hopi villages and to the neighboring Navajos. Prior to the availability of automobiles and suitable roads, burros and horses served as the primary means of transportation.

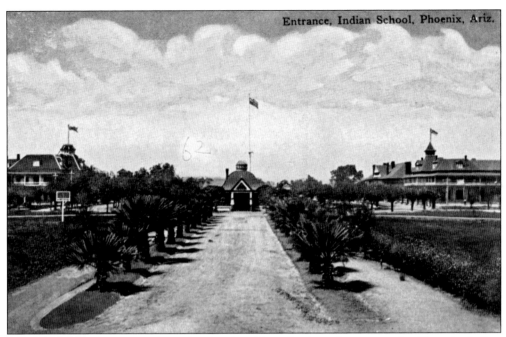

Initially called the U.S. Industrial School at Phoenix, later known as the Phoenix Indian School, it was founded in 1891 as a coeducational, federal institution for Native American primary and secondary students. The campus had 14 brick and 20 frame buildings, including a large schoolhouse, a two-story building containing employee quarters and a student dining hall, a large six-room shop for vocational training, and several dormitories. Field crops were cultivated and animal husbandry practiced to contribute to the vocational education of the students and the school's self-sufficiency. The school continued until 1988 when it was closed by an act of Congress.

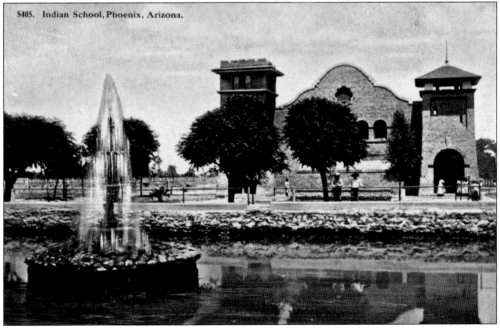

5405. Indian School, Phoenix, Arizona.

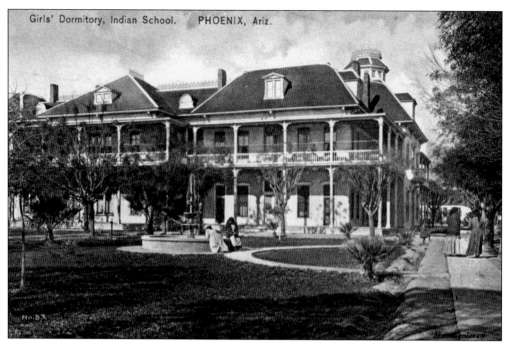

This early view from around 1915 offers a close-up of the girl's dormitory at the Phoenix Indian School. The education of girls focused on training for the household, including sewing, cooking, and laundry skills.

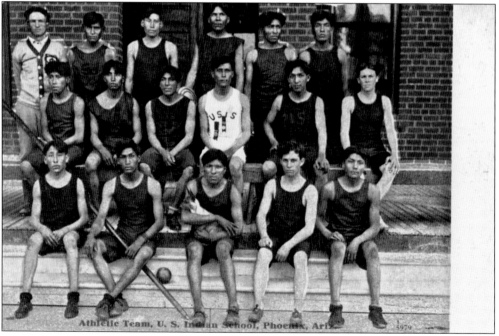

Participation in athletic teams was an important activity at Native American schools. This 1920s image shows the Phoenix Indian School's track-and-field team.

# BIBLIOGRAPHY

Bailey, Garrick and Roberta Glenn Bailey. *A History of the Navajos: The Reservation Years.* Santa Fe: School of American Research Press, 1986.

Braatz, Timothy. *Surviving Conquest: A History of the Yavapai Peoples.* Lincoln, NE: University of Nebraska Press, 2003.

Clemmer, Richard O. *Roads in the Sky: The Hopi Indians in a Century of Change.* Boulder, CO: Westview Press, 1995.

Erickson, Winston P. *Sharing the Desert: The Tohono O'odham in History.* Tucson, AZ: University of Arizona Press, 1994.

Goodwin, Grenville. *The Social Organization of the Western Apache.* Chicago: University of Chicago Press, 1942.

Kelly, William H. *Cocopa Ethnography.* Tucson, AZ: Anthropological Papers of the University of Arizona, 1977.

McKee, Barbara, Edwin McKee, and Joyce Herold. *Havasupai Baskets and their Makers: 1930–1940.* Flagstaff, AZ: Northland Press, 1975.

McNitt, Frank. *The Indian Traders.* Norman, OK: University of Oklahoma Press, 1962.

Ortiz, Alfonso. *Handbook of North American Indians, Volume 10: Southwest.* Washington, D.C.: Smithsonian Institution, 1983.

Perry, Richard J. *Apache Reservation: Indigenous Peoples and the American State.* Austin, TX: University of Texas Press, 1993.

Russell, Frank. *The Pima Indians.* Tucson, AZ: University of Arizona Press, 1975 (Re-edition).

Spicer, Edward H. *Pascua: A Yaqui Village in Arizona.* Chicago: University of Chicago Press, 1940.

Spier, Leslie. *Yuman Tribes of the Gila River.* Chicago, IL: University of Chicago Press, 1933.

Weigle, Marta, and Barbara A. Babock, eds. *The Great Southwest of the Fred Harvey Company and the Santa Fe Railway.* Phoenix: Heard Museum, 1996.

# DISCOVER THOUSANDS OF LOCAL HISTORY BOOKS
## FEATURING MILLIONS OF VINTAGE IMAGES

Arcadia Publishing, the leading local history publisher in the United States, is committed to making history accessible and meaningful through publishing books that celebrate and preserve the heritage of America's people and places.

Find more books like this at
**www.arcadiapublishing.com**

Search for your hometown history, your old stomping grounds, and even your favorite sports team.